The Snowy Day *and the Art of*
Ezra Jack Keats

The Jewish Museum, New York
Under the auspices of the Jewish
Theological Seminary of America

**Yale University Press, New Haven
and London**

The Snowy Day
and the *Art* of
Ezra Jack Keats

Claudia J. Nahson

with an essay by Maurice Berger

The Snowy Day and the Art of Ezra Jack Keats is supported by a generous grant from the Ezra Jack Keats Foundation. Additional support has been provided by the Joseph Alexander Foundation and the Winnick Family Foundation.

This book has been published in conjunction with the exhibition *The Snowy Day and the Art of Ezra Jack Keats,* organized by The Jewish Museum.

The Jewish Museum, New York: September 9, 2011–January 29, 2012
Eric Carle Museum of Picture Book Art, Amherst, Massachusetts: June 26–October 14, 2012
Contemporary Jewish Museum, San Francisco: November 15, 2012–February 24, 2013
Akron Art Museum, Ohio: March–June 2013

Designed by Steven Schoenfelder
Printed in China by Regent Publishing Services Limited

The Jewish Museum
1109 Fifth Avenue
New York, New York 10128
thejewishmuseum.org

Yale University Press
PO Box 209040
New Haven, Connecticut 06520-9040
yalebooks.com

*Library of Congress
Cataloging-in-Publication Data*
Nahson, Claudia J.
 The snowy day and the art of Ezra Jack
Keats/Claudia J. Nahson ; with an essay
by Maurice Berger.
 p. cm.
 Published in conjunction with an exhibition held at the
Jewish Museum, New York, Sept. 9, 2011–Jan. 29, 2012.
 Includes bibliographical references and index.
 ISBN 978-0-300-17022-1 (alk. paper)
 1. Keats, Ezra Jack—Exhibitions. 2. Keats, Ezra Jack.
Snowy day—Exhibitions. 3. Keats, Ezra Jack—Criticism and
interpretation. 4. Picture books for children—
Social aspects—United States—History—
20th century—Exhibitions.
 I. Keats, Ezra Jack. II. Berger,
Maurice. III. Jewish Museum
(New York, N.Y.) IV. Title.
NC975.5.K38A4 2011
741.6'42092—dc22
2011007880

A catalogue record for this book is available from the British Library.
The paper in this book meets the guidelines for permanence and durability of the
Committee on Production Guidelines for Book Longevity of the Council on Library Resources.

10 9 8 7 6 5 4 3 2 1

On the front cover: "After breakfast he put on his snowsuit and ran outside" (detail), final illustration for *The Snowy Day,* 1962, collage and paint on board, 9⅜ × 19½ in. (23.8 × 49.5 cm); on the back cover: "On his way to meet Peter, Archie saw someone new on the block" (detail), final illustration for *Hi, Cat!* 1970, paint and collage on board, 10¾ × 20 in. (27.3 × 50.8 cm)
On the title page: detail from Pl. 20
On this page: "He jumped off his shadow. But when he landed they were together again," final illustration for *Whistle for Willie,* 1964, collage and paint on board, 10 × 20 in. (25.4 × 50.8 cm)
On p. vi: "Archie laughed and said, 'We sure fooled 'em, didn't we?'" (detail), final illustration for *Goggles!* 1969, paint and collage on board, 10½ × 20⅝ in. (26.7 × 52.4 cm)
On p. xi: detail from Pl. 14
On pp. xii–1: detail from Pl. 25
On pp. 28–29: detail from Pl. 24

Contents

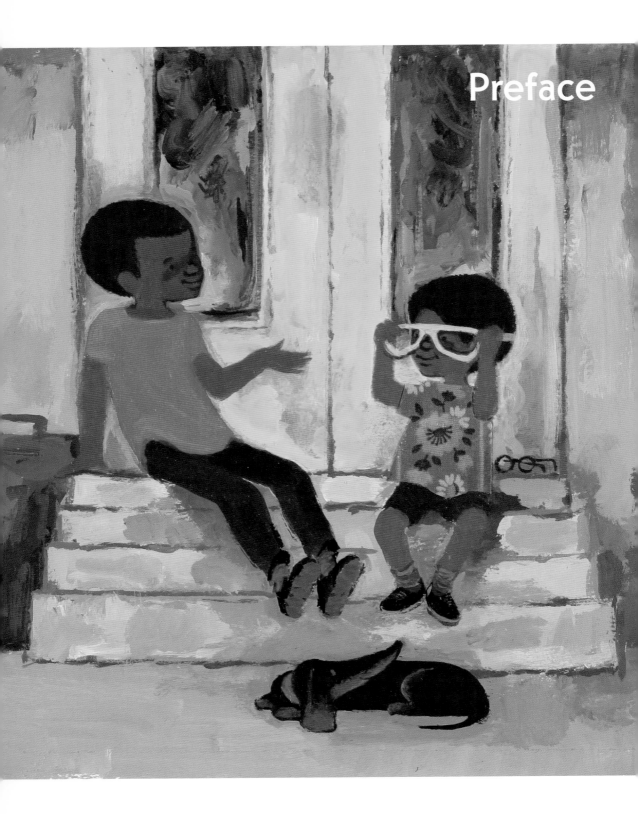

Archie, Amy, and Louie—some of Ezra Jack Keats's most beloved creations—have countless adoring fans, young and old; and Peter, that endearing little boy with a red-hooded outfit, has acquired an almost iconic quality. But Keats himself is not as familiar to his audience. Because *The Snowy Day*, the book that propelled his career in children's literature, and six subsequent stories he also both wrote and illustrated feature an African-American protagonist, many people have assumed that Keats was African-American. Moreover, it is not widely known that he was not always Keats, but was born Jacob (Jack) Ezra Katz to Jewish immigrant parents in Brooklyn. When young Jack first displayed an artistic talent by doodling over the kitchen tabletop in his tenement home, his mother refused to wash it off. Instead, she covered her son's drawings with the Sabbath tablecloth, proudly unveiling them for visiting neighbors. His father's routine reading aloud of the "Bintel Brief," the legendary advice column of the Jewish daily *Forward,* would often put Jack to sleep. The newspaper's editor offered simple answers to immigrants' problems, while Jack himself was living in "the cradle of enormous problems"—his family's struggle to eke out a living during the Depression. Sentimental Yiddish songs played on a newly purchased phonograph—a luxury the artist could account for only as a result of his family's suddenly "coming into some extra money."[1] It is not surprising, therefore, that from his beginnings as an artist Keats would identify with the downtrodden, and it certainly explains why, in his books for children, inner-city kids reign supreme.

Given The Jewish Museum's commitment to the presentation of work by socially engaged artists, we are both honored and gratified to showcase the first large-scale survey of Ezra Jack Keats's

art in this country, complemented by the present volume. This book
and the accompanying exhibition could not have come to fruition
without the continued support and generosity of the Ezra Jack
Keats Foundation and its director, Deborah Pope. It was she who
first approached the museum to spark our interest in organizing an
exhibition that would pay tribute to Keats's remarkable legacy and
celebrate the fiftieth anniversary of the publication of *The Snowy
Day* (1962), a landmark in children's literature. Our exploration
of the work of Jewish illustrators and authors in recent years,
with exhibitions on the art of Maurice Sendak, William Steig, and
Margret and H. A. Rey, made The Jewish Museum an ideal venue
for Deborah's vision. She soon became the perfect collaborator,
facilitating every step of the way while she graciously answered
our numerous questions and shared enlightening facts and memories
about Keats and his lifelong friendship with her parents, Martin and
Lillie Pope, steadfast advocates and exhibition lenders.

The other partner in this endeavor was the de Grummond
Children's Literature Collection, the main source for the original
art and documentary material featured in the exhibition. Located
at the McCain Library and Archives of the University of Southern
Mississippi in Hattiesburg, the de Grummond is a leading institution
in its field and is the repository of Ezra Jack Keats's original art
and papers. Our gratitude goes to Carole Kiehl, dean of university
libraries, who believed in our project from its inception. The
dedication and support of the de Grummond's curator, Ellen
Ruffin, was unsurpassed. Her insights into children's literature in
general and Keats in particular, her humor and marvelous southern
hospitality, made my research visits a true pleasure. She never tired
of chaperoning a nondriving vegetarian curator from New York, and
always ensured that I was well fed and transported to and from the
library, adding her own interesting comments about Hattiesburg on
the way. I am deeply indebted to her.

Special thanks are due as well to Danielle Bishop, manuscript
processor at the de Grummond, who answered numerous research

queries, and to Jennifer Brannock, special collections librarian, and Peggy Price, curator of special collections, at the McCain Library and Archives. All three greatly expedited my research by retrieving materials in advance of my visits, so that these could be readily available for consultation; I was thus able to study a great volume of works in a highly efficient manner. At the de Grummond, I was fortunate to cross paths with Virginia McGee Butler, a writer and retired teacher, and a lover of Keats's art and stories. She happily shared her valuable research lists and findings, and kindly devoted her time to make me feel welcome while I was in Hattiesburg. Brian Alderson's in-depth monograph on the artist, *Ezra Jack Keats: Artist and Picture-Book Maker* (1994), and the companion *Ezra Jack Keats: A Bibliography and Catalogue* (2002), offering a comprehensive guide to the de Grummond's holdings, were frequently consulted sources.

This book is greatly enriched by Maurice Berger's insightful essay on the impact of *The Snowy Day*, Anna Jardine's thoughtful editing, and Steven Schoenfelder's handsome design. The images of Keats's vibrantly colored paintings and collages were generously furnished by the Ezra Jack Keats Foundation. Additional images were obtained from the de Grummond through the good offices of Amanda McRaney, manager of digitization. Michelle Komie deftly oversaw the publication of this volume at Yale University Press.

Within The Jewish Museum, a number of staff members made this exhibition and the accompanying publication possible. I am most grateful to Emily Casden, curatorial assistant, on whom I relied heavily in all aspects of the project. Her serious commitment to the subject at hand, exceptional research skills, and wonderful disposition contributed greatly to the success of our undertaking, and made every phase of it a delight. Thanks are due to Joan Rosenbaum, former Helen Goldsmith Menschel Director of The Jewish Museum, for her inspiring leadership; to Ruth K. Beesch, deputy director for program, for her continued guidance; and to Susan L. Braunstein, chair of curatorial affairs, for

her constant support. The early planning for this book benefited highly from discussions with Michael Sittenfeld, former director of publications at the museum. His successor, Eve Sinaiko, took on the coordination of this publication with a very compressed schedule, and smoothly shepherded it through its completion. Thanks also to Sarah Himmelfarb, director of program advancement, institutional giving, for her fund-raising efforts on behalf of the project, and to Anne Scher, director of communications, and Alex Wittenberg, communications coordinator, for diligently promoting the exhibition. Jane Rubin, director of collections and exhibitions; Jessica Nilsen, assistant registrar; and Jennifer Ayres, exhibitions coordinator, are to be particularly commended for overseeing the preparation and installation of the exhibition. As always, Al Lazarte, director of operations, and his staff efficiently readied the galleries, while a team of creative consultants translated the exhibition concept into a reality. Exhibition designers Barbara Suhr and Kris Stone's elegant yet playful installation is further enhanced by the clever graphic program devised by Urshula Barbour and Paul Carlos of Pure+Applied, and by Miranda Hardy's theatrical lighting.

Ezra Jack Keats once said that "if we all could really see ('see' as perceive, understand, discover) each other exactly as the other is, this would be a different world."[2] Entering Keats's universe grants us a glimpse of that world, a world in which "kids are real regardless of color," a colorful world where honesty prevails.[3] Speaking of his inspiration for *The Snowy Day*, Keats explained: "I grew up in a slum area and when it snowed it was a transformed city—very quiet, very poetic and so different that I felt it in my bones."[4] No matter how we feel in our bones, a visit to "Keats's neighborhood" is always restorative. Peter and friends can be counted on when we need to be reminded of that simple pleasure of which we are often so oblivious—the joy of being alive.

Claudia J. Nahson, *Curator*

notes

1. Lee Bennett Hopkins,
"On Ezra Jack Keats," *The
Lion and the Unicorn* 13,
no. 2 (December 1989),
p. 56; Ezra Jack Keats,
unpublished autobiography,
Ezra Jack Keats Papers,
de Grummond Children's
Literature Collection,
McCain Library and
Archives, University of
Southern Mississippi, box
70, folders 4, p. 3; 16,
p. 2; 21, p. 7.

2. Kenneth A. Marantz,
"Ezra Jack Keats' *The
Snowy Day:* The Wis-
dom of a Pure Heart," in
*Touchstones: Reflections
on the Best in Children's
Literature,* vol. 3: *Picture
Books* (West Lafayette,
Ind.: Children's Literature
Association, 1989), p. 70.

3. Ezra Jack Keats, as
quoted in Margo Huston,
"Honesty Is Author's Policy
for Children's Books,"
Milwaukee Journal, March
28, 1974, part 2, p. 6.

4. Ezra Jack Keats, as
quoted in Brian Alderson,
*Ezra Jack Keats: Artist
and Picture-Book Maker*
(Gretna, La.: Pelican,
1994), p. 133.

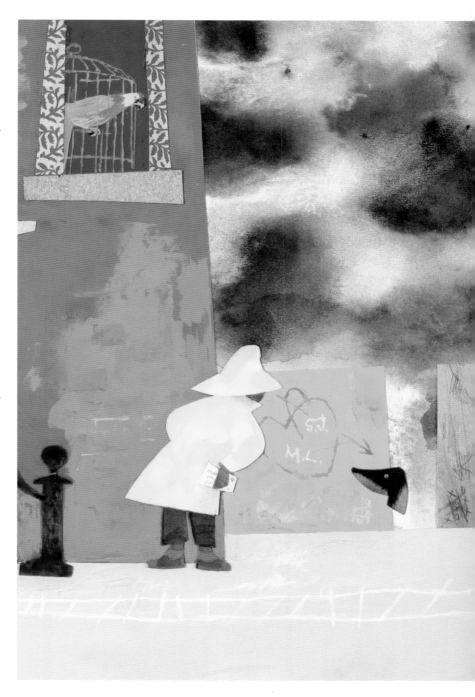

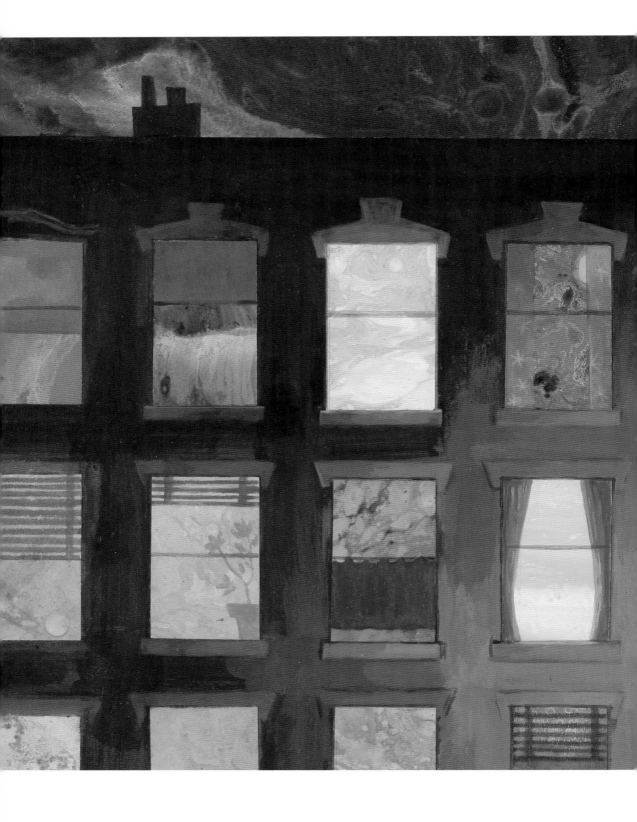

Bringing the Background to

the Foreground, or The Poetry of a Trash Can

Claudia J. Nahson

Everything in life is waiting to be seen!
— *Ezra Jack Keats*

Born Jacob (Jack) Ezra Katz to Eastern European Jewish immigrant parents in Brooklyn, Ezra Jack Keats (1916–1983) had a poverty-stricken childhood. Most of his picture books are rooted in personal memories of growing up in the East New York neighborhood, one of the most deprived in the city. His stories are usually situated in dilapidated urban environments inspired by his early surroundings (Pl. 16). Keats has been praised for "the consistency with which he transmutes the everyday [existence] of poor American children living in seedy apartments to something rich and teeming with possibilities."[1] His work is pioneering—no earlier books for the young featured these gritty landscapes. Keats not only made such backgrounds an integral part of his stories, but he also rendered the squalid city settings beautiful through his mastery of collage and his expressive painting (Pls. 4, 17). Brian Alderson, the author of an in-depth monograph on the artist, has called Keats "a colorist celebrating the hidden lives of the city kids," and a "mood explorer" rather than a storyteller: a number of his books are, in fact, more intent on delving into particular feelings than in developing a plot.[2]

Keats's creations are not the staple of children's literature. He revolutionized the field by introducing an African-American boy named Peter as the protagonist of *The Snowy Day* (1962), the first picture book that Keats both wrote and illustrated (Pls. 2, 3). Peter went on to grow and thrive in six other books: *Whistle for Willie* (1964), *Peter's Chair* (1967), *A Letter to Amy* (1968), *Goggles!* (1969), *Hi, Cat!* (1970), and *Pet Show!* (1972). The rationale for featuring an African-American protagonist was plain and simple to the author. Keats, who until writing *The Snowy Day* had been illustrating books written by other authors, observed that none of the manuscripts he had worked on had an African-American child as the main character. "My book would have him there simply because he should have been there all along."[3] The earlier casting of Juanito, a Puerto Rican character, as the protagonist in *My Dog Is Lost!*

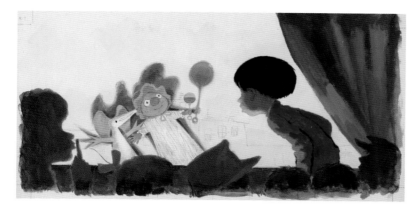

Fig. 1. "'Hello!' he said." Final illustration for *Louie*, 1975. Paint on board, 9⅞ × 19⅞ in. (25.1 × 50.5 cm)

(1960) was a groundbreaking move on the part of Keats and his coauthor, Pat Cherr, and likely paved the way for Keats's creation of Peter. Louie, the shy protagonist of a number of his books, "grew out of a story Keats heard from a Japanese puppeteer about a mentally challenged boy who yelled 'Hello!' at the puppets in the middle of a show" (Fig. 1).[4] These neglected characters, who had hitherto been living in the margins of picture books or had simply been absent from children's literature, take pride of place in Keats's oeuvre. In his unpublished autobiography the artist speaks of wanting to communicate that these children are actual presences: "When I did my first book about a black kid I wanted black kids and white kids to know that he's there."[5]

As he grew up in East New York, feeling "not there" or in the background was familiar for Jack Katz. The artist once equated an early job of his, erasing pencil lines, whiting out ink spots, and inking in background drawings for the comics industry in the 1940s, to his life growing up as an outsider. "I saw an ad in the paper—somebody wanted an assistant—what is known as a clean-up and background man. Well, I thought I was great as a background man. I'd been in the background for a long time, and figured I might as well make some money at it" (Fig. 2).[6] This may explain why in Keats's art the often overlooked takes center stage. Keats might be called

Fig. 2. Keats, "the background man" (by window at right) at *Captain Marvel* comics studio, c. 1942

the Edward Hopper of children's literature; in his work, as has been said of Hopper's art, the ordinary is made extraordinary.[7] Extant juvenilia include a few neighborhood scenes reminiscent of Hopper's work (Figs. 3, 4), which Jack Katz also copied.[8] But while Hopper focused on the situation of adult middle-class America, Keats zoomed in on the plight of the inner-city young, his mature work revealing an interest in the clutter rather than the sparseness of urban life, with crowded surroundings often emphasizing his protagonists' isolation. Hopper's images of urban alienation were only one point of artistic departure. Honoré Daumier's depictions of the working class and the disenfranchised impressed the young Keats greatly, as seen in his award-winning painting *Shantytown* (Pl. 1).[9]

"I love city life," Keats once said. "All the beauty that other people see in country life, I find taking walks and seeing the multitudes of people (all the manifestations of people, one layer over another) and children playing. . . . I was a city kid. I wouldn't think of setting [my stories] anywhere I didn't know."[10] Mostly self-taught, Keats attended his first life-drawing class at Greenwich House, when he moved to Manhattan from Brooklyn a few years after graduating from high school in the mid-1930s. He later recalled that "there were some pretty good artists in the class, one of them drew particularly strong figures. I remember his name, Jackson Pollock." When the teacher's methods became too rigid for his tastes,

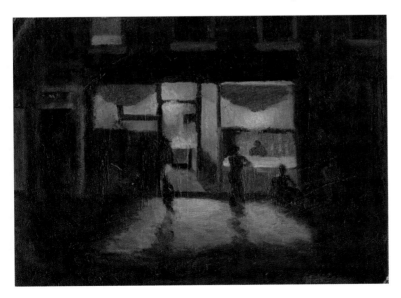

Fig. 3. Untitled (candy shop at night), c. 1934-1936. Oil on board, 12 × 16 in. (30.5 × 40.6 cm)

Keats abandoned the course. "Instead of class, I began to sketch evenings in the cafeterias and subways. The people you saw! The whole city was there to be drawn."[11]

Keats's appreciation for beauty in the quotidian developed early, first encouraged by his mother, who on one hand urged him to pursue his artistic talent, and on the other deprived him of emotional nurturing. She would often wake her young son to gaze at the beautiful dawn lights.[12] Growing up during the Great Depression, the youngest child of a loveless marriage, Jack Katz thought that "life was measured by anguish."[13] In order to cope with this grim reality, he "holed up and drew," his youthful output ranging from copies of "photos of famous actors and gangsters" to "scenes from the window—and an occasional graveyard."[14] From a young age, art afforded him a way to escape the harsh circumstances of life at home. "Painting was my sky hook," he wrote.[15] "I didn't really understand it, but all of the pain, all the nuances of feeling, all the senses of poetry and music when I'd watch the sunset or the sunrise, or watch people, I only had one place to take it, and I painted."[16]

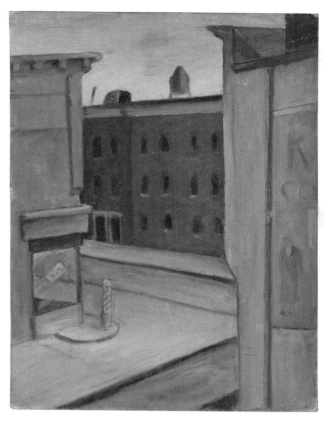

Fig. 4. Untitled (street corner), c. 1934–1936. Oil on canvas board, 16 × 12 in. (40.6 × 30.5 cm)

The artist's lengthy preoccupation with Louie, the protagonist of four of his picture books—*Louie* (1975), *The Trip* (1978), *Louie's Search* (1980), and *Regards to the Man in the Moon* (1981)—calls for some examination. In contrast to Peter, Keats's most celebrated creation, Louie never "grows older." Instead, the introverted boy appears to be in a state of arrested development, as he wrestles from book to book with a cluster of difficult emotions, a sense of isolation and invisibility, and an inability to reach out to his peers—the same elements that hindered Keats's own emotional and artistic growth. It is not too far-fetched, therefore, to view Louie as

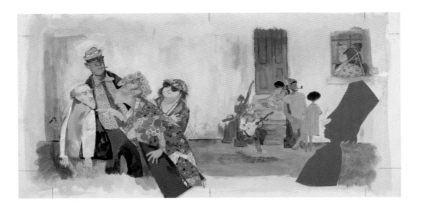

Fig. 5. "Louie passed quite a few people." Final illustration for *Louie's Search,* 1980. Paint and collage on board, 12 × 22 in. (30.5 × 55.9 cm)

a stand-in for the artist.[17] The fact that he introduced Louie toward the end of his career is significant, and may indicate that Keats felt ready to confront his past head-on only later in life; Peter had been a rather hopeful version of his own young self until then. No image better communicates the emotional burden young Jack Katz must have borne growing up in East New York than the scene featuring a solitary Louie, hunched over with hands in pockets, walking past a wall exploding with graffiti—a collage tour de force (Pl. 26). In *Louie's Search,* the artist depicts Louie first as a shadow, a non-presence, in his own neighborhood bustling with life (Fig. 5). Keats wrote of feeling invisible as a child, of "walking around like a shadow."[18] When remembering the kindness bestowed on him by one of his older brother's friends (actually called Louie—the character's name is probably a tribute to the young man), the artist described his perplexity at being addressed as a real presence in the world: "I was surprised that he perceived, that he saw me, that I occupied space."[19]

Keats spoke of his early adulthood as an existence in the margins of society: "When I traveled on the subway, I used to stand at the end of the car . . . and I found that there were certain silent isolated people, particularly during the Depression, who stood in that area which was sort of the lower depths. . . . It was a hangout [where] certain souls would gravitate, where they could be alone and silent and away from those whom the world had accepted."[20] On one occasion, he found a kindred spirit in a homeless man at a diner, both of them having wound up "at the same end of the bar where sort of the non existent people seemed to hover, half tangible, half transparent, sort of semi opaque."[21] These experiences may account

for the important role of shadows in Keats's art and for the frequent interplay between the "real" and the "perceived" in his illustrations. In *Dreams*, the gigantic shadow cast by a tiny paper mouse that Roberto has made in school saves Archie's kitten when it is threatened by a vicious dog, in a true David-and-Goliath subplot (Fig. 6). In *The Trip*, Louie's old neighborhood, a previously familiar territory, turns menacing with overpowering shadows when the lonely boy decides to take an imaginary journey back to his old haunts (Fig. 7). A reviewer of *Louie* praised Keats for his "dramatic use of theatrical brilliance and brooding shadow."[22] Louie's story is so filled with drama that *The Trip* was adapted for the theater, with music and lyrics by Stephen Schwartz, of *Wicked* fame. One of the songs, "Shadows," calls for a choreographed sequence of Louie and his shadows as the boy pleads:

Now if I can just get by this one dark alley . . .
Make your mind up
Or by shadows you could wind up
Trapped!

Keats's illustrations for *The Trip* were used to design the sets and costumes for the production, but he died several months before the musical opened in December 1983. Now titled *Captain Louie*, with

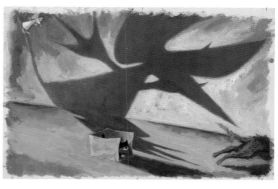

Fig. 6. "The shadow grew bigger—and bigger—and BIGGER! The dog howled and ran away." Final illustration for *Dreams,* 1974. Paint on board, 13½ × 20⅝ in. (34.3 × 52.4 cm)

Fig. 7. "He turned around and ran—as fast as he could." Final illustration for *The Trip,* 1978. Collage, paint, crayon, and pencil on board, 12 × 22 in. (30.5 × 55.9 cm)

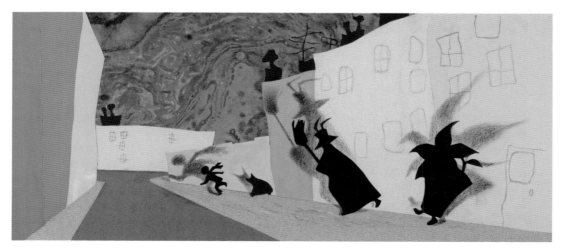

a libretto by Anthony Stein, it continues to tour through amateur productions licensed by Music Theater International, to the delight of audiences young and old.[23]

The opening lines of *Louie's Search*—"What kind of neighborhood is this? . . . Nobody notices a kid around here"—not only state the predicament of most children growing up in indigent conditions but also convey what is at the heart of Keats's work: rendering visible what has hitherto been invisible to his audience, be that an inner-city child, a message graffitied on a wall (Fig. 8), or a dilapidated building. For Keats's biographer Brian Alderson, the artist "enjoyed scattering among his pages barely relevant images that gave depth, authenticity, and often charm to his back-street milieux"; his picture books are filled with "distractions and contingencies." The images

that Alderson calls distractions and contingencies are necessary— and not just to give Keats's stories a "proper flavor of reality."[24] They are in fact the background elements the artist is committed to bring to the foreground in his books. A critic described taking a walk with Keats in his neighborhood as a journey of discovery, an experience akin to entering the world of his picture books: "Before walking with Keats, most people might notice one, or at most two, of the things he points out; afterwards, even alone, there's little you will miss. The special vision of this special man is in his books as well. He gives his readers colors and textures and objects that can forever change the way they view the world."[25]

Fig. 8. Dust jacket. Final illustration for *A Letter to Amy*, 1968. Watercolor, collage, and paint on board, 10¼ × 21½ in. (26 × 54.6 cm)

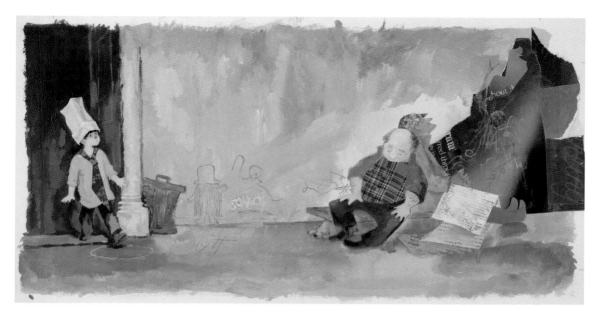

Fig. 9. "'What kind of neighborhood is this?' thought Louie." Final illustration for *Louie's Search,* 1980. Paint and collage on board, 12 × 22⅛ in. (30.5 × 56.2 cm)

Often lonely and in great need of attention and affection, Keats's characters are frequently depicted canvassing their familiar neighborhood turf in search of something that might bring about a sense of renewal or someone who might display nurturing feelings toward them—Louie, for example, hopes for a father in *Louie's Search*, and journeys back to his old neighborhood looking for familiar places and people in *The Trip*. The characters' real or imaginary outings are often propelled by the necessity to find solace from oppressive feelings at home, feelings brought about by the lack of friends in a new neighborhood, as in *The Trip*, or by the arrival of a new sibling, as in *Peter's Chair* (Pl. 13). Growing up, Keats himself would take long walks "as far away from home as possible" to flee domestic unhappiness.[26] By constructing these kinds of narratives, he engages his audience in his protagonists' quests, and leads readers to pause and look, to pay attention to the homeless men sleeping in the street (Fig. 9), the array of abandoned old doors (see Fig. 21), the cans filled with trash (garbage tended to overflow in Keats's neighborhood, recalled a friend, Martin Pope, who shared many of the same youthful experiences).[27]

One of the artist's seminal experiences as a child was his encounter with a pious Jew known in his neighborhood as Tzadik (in Hebrew, "righteous one"). This giant of a man whose "orange

beard, bushy brows, and massive head of fiery hair topped by a skullcap exploded around his face" was the inspiration for Barney, the larger-than-life character in *Louie's Search* (Figs. 10–11).[28] Tzadik led a reclusive and humble existence, eking out a living by carrying "big sacks of coal, or enormous hunks of ice on his back. Even pianos."[29] (Junk dealers were ubiquitous in Jack Katz's neighborhood during the Depression years.)[30] One day, while young Jack was playing with other children on the sidewalk, the doors of a nearby cellar unexpectedly swung open, catapulting the boy into the air. Bellowing in Yiddish, "Bums! Can't a man pray in peace in his own home?" the towering figure came up the cellar stairs and soon caught up with Jack. "Tzadik swooped down, grabbed me, lifted me high in the air, and held me there. 'Look up—look up—see? God is there! He's watching us all! He wants us to lead fruitful lives and do good acts. We weren't put on this earth to be loafers. Remember! Serve

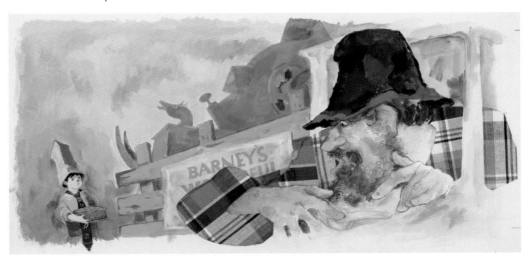

Fig. 10. Keats's journal notes on Tzadik, the inspiration for the character Barney in *Louie's Search*

Fig. 11. "The man in the truck turned around. He looked terrible!" Final illustration for *Louie's Search,* 1980. Paint and collage on board, 12 × 22 in. (30.5 × 55.6 cm)

the Lord!'"[31] After exhorting Jack to lead an observant Jewish life filled with purpose, Tzadik set him down and dismissed him with a "God watch over you, little herring." "I watched him walk down the block, stoop, pick through a pile of broken pieces of furniture, and carry most of it off under his powerful arms," Keats later recounted. "I went over to take a look at what was left. A small, smooth panel of wood caught my eye. I took it home with me; it might be good to paint on."[32] He immediately set to work on a scene of a cloudy sky,

which would become his first original painting (until then he had been copying other artists' works).[33] His mother, who had been observing him without his noticing, suddenly asked, "How come you're painting out here—on a piece of wood?" "I saw Tzadik carry away some broken furniture. He left this piece," Jack replied. She looked at the painting, then clasped his hand. "I couldn't remember her ever touching me," Keats wrote. "I think he gave you something, maybe it will save you," his mother told him. "Save me? From what?" Jack asked, perplexed. "Oh I don't know—maybe me," was her answer.[34]

Young Keats's meaningful encounter with Tzadik and the heartbreaking exchange between mother and son that ensued may explain why the artist decided to pose himself as Barney the junk-man in *Louie's Search* (Fig. 12). But Keats's tribute to the pious man extends far beyond this gesture. As Louie's quest unfolds, it becomes evident that Barney—whose thunderous temper and frightening demeanor may have misled the reader at first—is actually the father figure whom Louie and by extension Keats (Louie functions as a self-portrait of sorts) have been yearning for. The artist forces us to look again, and discover what is beautiful in a character we may have at first disliked or feared. While Tzadik left behind a wooden board, put to good use by young Jack, Barney ends up offering Louie the music box the junkman initially thought the child had stolen from him. "That thing never played like that for me before," Barney confesses. "Since it plays so good for you, Louie, why don't you keep it?" In real life Tzadik may have intentionally left behind the piece of wood, sensing that Jack would know what to do with it; in the book Barney offers the music box to Louie, whose appreciation for the delicate object makes it come alive. Tzadik gave Jack Katz the gift of faith in his own artistic talent, and it was art that eventually saved him from his past. Benjamin Katz's ambivalent attitude toward his son Jack's artistic inclination—openly critical, but privately encouraging—likewise may have influenced the shaping of a character such as Barney.

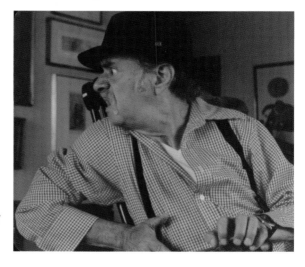

Fig. 12. Keats posing as the model for Barney in *Louie's Search,* 1980

Through Barney, perhaps, Keats tried to channel his mixed feelings about his father, whom he was taught to despise by his mother and sister while he was growing up, but whom he came to somewhat understand and appreciate much later in life, when the elder Katz was long gone.[35]

Keats revisits yet another seminal, and in this case traumatic, childhood experience—being the victim of bullying—in the book *Goggles!* He grew up on East New York's Vermont Street; one block over, Wyona Street was considered dangerous territory, "where the enemy, the Wyonas, lay in wait" (Fig. 13).[36] In his autobiography, Keats recounted how one hot summer night he and his friend Teddy were accosted by bullies. "The street light was broken. It was dark. Looking ahead we saw a semi-circle of the big guys straddling the street. . . . We had walked right into a trap!" The group of boys pounced on Teddy, who managed to overpower them after refusing to give up on his pal—"a skinny kid who drew pictures."[37] But with Jack's feelings of vulnerability, brought about by his small physique and his artistic bent, also came the realization of the power that his art could exercise on those who tried to overtake him. "One day," he related, "as I crossed the street carrying a painting to show Mr. Gordon, the candy store man, a gang of big tough kids intercepted me. One guy ripped it from my hands and passed it around." Jack feared that one of the bullies would "punch his fist through it." Instead, after carefully studying Jack's version of a watchmaker by Norman Rockwell, faithfully copied from a *Saturday Evening Post* cover, the older boy exclaimed "Geez!" and gently returned the painting to Jack, dismissing him with a "So long, Doc!"[38] Art, therefore, was a powerful tool that helped him navigate the dangers of his inner-city childhood and rise above its limitations.

"The only time anyone knew that I was around was when I drew pictures," the artist once stated. "But aside from that, I faded from view." Art not only rendered him "visible" but also offered him rare moments of bonding with his mother, who otherwise was often distant and harsh. "When I painted my mother took my side. Because then both of us could escape through the painting. . . . We both could create things together, and take off—take flight, be in different places, see a blank board or a blank canvas or burlap or whatever

come to life, take on moods."[39] No wonder that imagination and creativity are central to the artist's work. In his stories, art-making frequently provides a much-needed escape or leads to conflict resolution, galvanizing characters into action. A homemade puppet sparks life into the protagonist of *Louie*, one of Keats's most tender

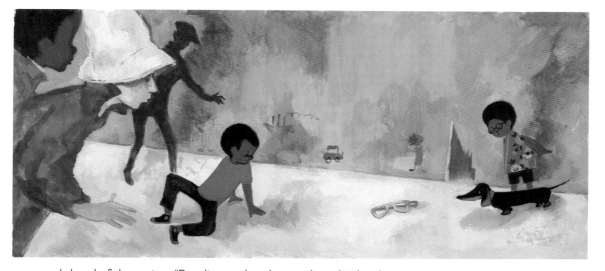

Fig. 13. "The next thing he knew he was knocked to the ground." Final illustration for *Goggles!* 1969. Paint and collage on board, 10 × 20 in. (25.4 × 50.8 cm)

and deeply felt stories. "Reading and understanding this book can be a spiritual experience," wrote one reviewer; "memorable, moving," another critic observed.[40] A reserved youngster who has never exchanged a word with the other children in the story, Louie comes out of his shell and breaks his silence when he is smitten by Gussie, one of the puppets made by Susie and Roberto in preparation for their show (see Fig. 1).[41] Throughout the scenes featuring the puppet show, Keats uses alternating vantage points. For the author and educator W. Nikola-Lisa, "the more Keats alternates views pictorially . . . the more the viewer becomes unsure as to which 'reality' is the made up one, which reality is the pretense."[42] But Keats seems to be interested in presenting two simultaneous rather than two alternating realities; he has the reader see the same situation through the eyes of Susie and Roberto, who view Louie as a lonely child sitting by himself in the audience, and through the eyes of Louie, for whom the puppets have become living presences: outlined by their shadows, they almost burst out of the confines of the page.

In *The Trip*, feeling alienated after moving to a new neighborhood where he knows "no kids, no dogs, and no cats," and where

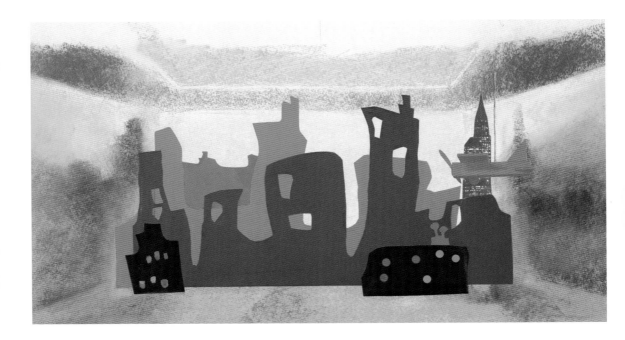

Fig. 14. Inside view of Louie's shoebox diorama. Final illustration for *The Trip*, 1978. Collage and pastel on board, 12 × 22 in. (30.5 × 55.6 cm)

there aren't even "any steps in front of the door to sit on," Louie turns to art-making: he builds a peep box that allows for an imaginary journey back to his old block (Fig. 14). Still, as Nikola-Lisa remarks, the prop or "object" in many of Keats's stories "exists as a reminder of the necessary—and often frail—relationship between concrete reality and personal fantasy."[43] In *Louie's Search*, the hitherto withdrawn protagonist decides to take matters into his own hands and, emboldened by a tall paper hat of his own creation and a nose painted red, he sets out: "Maybe someone would notice him—someone he'd like for a father" (see Fig. 9). His search yields the desired results in the person of Barney, the peddler. In *Regards to the Man in the Moon*, when Louie is derided for having a "junkman" as a parent, Barney springs into action: "They should know better than to call this junk! All a person needs is some imagination! And a little of that stuff can take you right out of this world." Immediately they set to work on "Imagination I," a makeshift capsule that will send Louie and Susie on a fantastic trip to space.

The children's "return voyage" in *Regards to the Man in the Moon* offers a dramatic view of lower Manhattan and the World Trade Center (Pl. 30). The incandescent image he created of the early-1980s New York skyline now stands as a moving tribute to the

Twin Towers that were destroyed in 2001. Nikola-Lisa called *Regards* a showcase for "Keats's foundational belief that bodies in motion activate and sustain an insatiable curiosity" and "a *tour de force* of Keatsean philosophical truth combining elements of constructive play and spatial exploration."[44] Yet the picture book drew negative comments from most reviewers, as well as from Brian Alderson, who nevertheless acknowledged that "there is much to admire in the technical skill with which Keats designs these fantasies" (referring also to his illustrations for *The Trip*). "In narrative terms, however, they seem forced," Alderson contended, agreeing with another writer that "that blatant recourse to imagination . . . isn't very imaginative, and the whole junk-is-what-you-make-it angle is pretty trite. The set-up looks to be a narrative excuse for the 'phantasmagoric outer-space collages.'"[45] Still, *The Trip* and *Regards to the Man in the Moon* are very much grounded in Keats's own life experience, which may account for their "phantasmagoric" quality. In these and other stories Keats the man-artist is looking back on Jack Katz, the talented and imaginative yet introverted youth, personified by Louie. In *The Trip*, Keats goes as far as to make a cameo appearance, smiling from a window at upper right as he returns to the old neighborhood, now a happier venue than it was in his childhood, the shadows, once so threatening, finally unmasked (Pl. 27).

Art can also provide a rare moment of beauty and magic, as experienced by the two young characters in *Apt. 3* (1971), sometimes considered Keats's most original though most testing picture book (Fig. 15). An autobiographical story, it conflates several episodes from

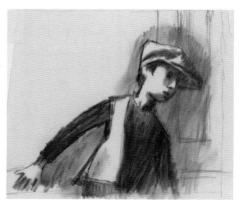

Fig. 15. "Sam went into the hall and listened" (detail). Preliminary illustration for *Apt. 3*, 1971. Pencil on tracing paper mounted on board, 10½ × 22¾ in. (26.7 × 57.8 cm)

Keats's tenement childhood. He recalled "listening to the music coming through the courtyard and later helping a blind man down the street. When I realized what he could sense . . . what he could see . . . [those experiences] sort of fell together without planning it."[46] For Alderson, "the book took hold of Keats's imagination and led him towards an entirely different vision of the life that goes on behind the battered doors of the tenement block."[47] Keats considered it "one of the most important things I have done, in terms of my own

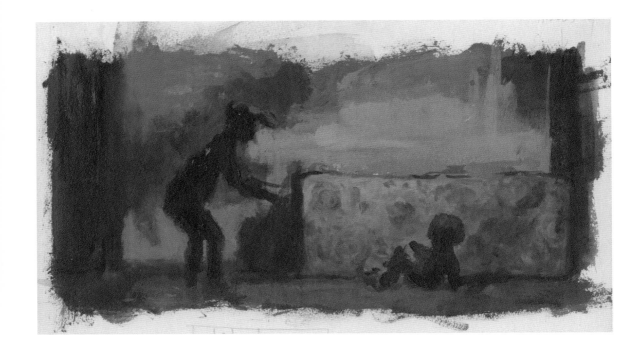

Fig. 16. "Ben bumped into an old, worn-out mattress." Preliminary illustration for *Apt. 3,* 1971. Paint on board, 7 ⅛ × 11 in. (18.1 × 27.9 cm)

personal satisfaction."[48] This sentiment is echoed in a letter the artist sent to his friend Isaac Bashevis Singer: "A book I have both written and illustrated has just been published. It is called *Apt. 3* and is based on some experiences I had as a child, and is most important to me. I am enclosing a copy for you and would very much like to know how you feel about it. I look forward to resuming our occasional walks and pleasant lunches. . . . Shalom, Ezra." Singer, winner of the Nobel Prize for literature in 1978, replied, "My answer to what you have written is: By all means!"[49]

Among Keats's most painterly, the illustrations for *Apt. 3* are set in claustrophobic interiors of narrow and dilapidated corridors and staircases, dimly illuminated by naked lightbulbs. The overall feeling is of a hermetic space devoid of humanity, with Sam and his young brother Ben as the sole inhabitants—a pair of survivors. Keats offers little visual respite in his scenes of urban squalor, forcing the reader to take a hard look at the situation of poor children in the city. The setting is so bleak that an abandoned flowery mattress gets the brothers' attention, a rare touch of color in the forsaken place (Fig. 16). Withholding bright colors until the end is indeed Keats's way of building to the story's conclusion. "If I want a very dramatic point in

the story," the artist explained, "I'll try to keep perhaps the first few pages, in terms of illustrations, relatively subdued in colors, or shape, or action. . . . And follow it with something quiet. But the impact is there and you lead up to it."[50] However inhospitable the surroundings, life is taking place behind the shut doors, with a multiplicity of smells and sounds traveling out to the corridors. The boys' quest is to find the source of the haunting music that seems to rise above the "loud, juicy snoring," the baby cries, the dog barks, and the domestic quarreling in the various dwellings. Alderson may be right in sensing that Keats's text for the book "cannot finally match up to the strange, shadowy luminosities of his extraordinary paintings."[51] The pictures rather than the words drive the plot, and as Alderson points out, we should not ignore the fact that Keats relies almost exclusively on painting instead of collage in his art for *Apt. 3*.[52] The story's dramatic nuances are better conveyed through painting, Keats's medium of choice during his early career, and the scaffold on which he constructed most of his images even when exploring collage to its fullest.

Ultimately the children locate the source of the music: a blind man playing a harmonica. "You want to hear some secrets? Listen," the musician tells his apprehensive young audience. Keats's claim that in his books he did not want to teach children anything, but wanted to "share something" with them, is put to the test in this intimate scene where two boys share their elating experience with the reader.[53] Just as the notes from the harmonica may show the children the path to unlock the blind man's heart, Keats's art is a key to understanding Keats the man. Alderson is correct in remarking that in *Apt. 3* the artist is striving for symbolism rather than the conveyance of a plot.[54] At the heart of the story is Keats's firm belief in the restorative power of art: no matter how indigent daily life can be, art, in the form of a beautiful piece of music or a painting, can make people soar to new heights, and rise above the misery at least for one precious instant. This is evident in Keats's treatment of the illustrations. By the time Sam and his brother fully experience the music, the palette has shifted from somber browns to glorious purples, a transformation echoed in the text: "He played purples and grays and rain and smoke and the sounds of the night. Sam sat quietly and

listened. He felt that all the sights and sounds and colors from out-side had come into the room and were floating around" (Pl. 23).

In *Apt. 3*, the sounds of the blind man's harmonica bring color into an otherwise dark and oppressive tenement interior. In *Dreams*, color travels out of the Brooklyn windows and into the night, and as the building's inhabitants begin to dream, darkness turns into incandescence. These are some of Keats's most splendid illustrations, where the combination of paint and marbleized paper reaches a pin-nacle (Pls. 24, 25). Whatever darkens the days of the tenement's occupants is all at once lifted, and as they enter the realm of dreams, color begins to suffuse them. Keats improves on his memories of stiflingly hot summer nights when he revisits them in *Dreams*.[55] As Alderson notes, the book is primarily a mood piece in the same vein as *Apt. 3*, the plot being merely a vehicle to convey the tenement's transformation from dusk to dawn. That Keats's books strive for the universal even when based on his most intimate recollections is suggested by the account of a young Japanese reader's reaction to *Dreams*. Keats's books have been particularly popular in Japan, a country the artist admired and visited. His third and last trip there, in 1977, was prompted by a letter he received from the mother of a nine-year-old boy, Akira Ishida, who had been killed in a traffic accident. Akira's favorite book had been *Peter's Chair*, and Keats had autographed the youngster's copy of the book during his first trip to Japan. Deeply affected by Akira's death, the artist visited the family and the boy's grave. Akira's mother told Keats how her son had seen spring flowers and waterfalls in the luminous tenement windows of *Dreams*, the last book he had read, the day before he died. She described his fascination with insects: "The world of unseen crea-tures more people don't notice. They are trodden over. This was the world he loved—an almost unseen world."[56] One can imagine how at home Akira felt amid Keats's gentle creations, in a world where the overlooked is brought forth.

Alderson has examined Keats's books, including *Goggles!* and *Apt. 3*, in relation to the work of other author-illustrators, such as Maurice Sendak, whose *A Sign on Rosie's Door* (1960) also deals with the doings of Brooklyn kids (Fig. 17). For Alderson, Keats stands out for his commitment to "downbeat authenticity," both in

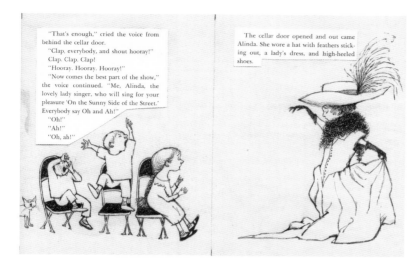

Fig. 17. Maurice Sendak (American, b. 1928). "'That's enough,' cried the voice from behind the cellar door." Final illustration for *The Sign on Rosie's Door,* 1960. Pen and ink on paper, 12⅛ × 16⅛ in. (30.8 × 50 cm). Maurice Sendak Collection, Rosenbach Museum & Library, Philadelphia

pictures and in words, his texts being rather simple and prosaic compared with Sendak's rhythmic writing. Yet Keats and Sendak share one main concern in their work: to show how children can survive and even thrive in the direst of circumstances. This common preoccupation probably stems from similar early biographies: like Keats, Sendak, the son of Eastern European Jewish immigrants, grew up in a poor Brooklyn neighborhood during the Depression. Sendak loves Rosie for her ability to get through the day by using her prodigious imagination, and a similar sentiment can be felt in Keats's great appreciation for the resourcefulness of city kids who "have to make their own world out of a city block."[57] Yet while Sendak's Rosie is a buoyant and hopeful stand-in for the artist, Keats's characters are often insecure and withdrawn self-portraits. His creations seem to inhabit a world between Rosie's block and the alleys frequented by Jack and Guy in *We Are All in the Dumps with Jack and Guy* (1993), Sendak's brutal wake-up call about child homelessness in America (Fig. 18).[58]

Although most of Keats's stories emanate directly from his difficult upbringing, they often feature a nurturing presence—a comforting parent, a complicit friend, or a friendly pet—whom the protagonist can call on when conflict arises. This is the kind of support system the artist lacked during his early childhood.[59] It has

been noted that in his books Keats "'corrects' the problems of his own home life."[60] The tendency to revise his life narrative through his work may have originated in Jack Katz's strong desire to change the course of his life early on; his petition for a legal name change to Ezra Jack Keats in 1947, at age thirty-one, was one of the first public manifestations of that desire. His growing up feeling invisible and unloved, the experiences of bullying and discrimination, and a postwar climate of pervading antisemitism may have contributed to that decision. The name change may have been his bold opening move toward becoming "a full-fledged citizen"—an awareness that, he confessed, took him many years to attain.[61]

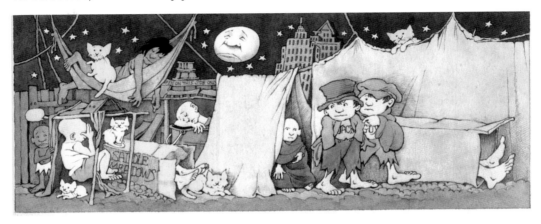

Fig. 18. Maurice Sendak (American, b. 1928). Title page. Final illustration for *We Are All in the Dumps with Jack and Guy*, 1993. Watercolor, pencil, and pen and ink on paper, 5½ × 14¾ in. (14 × 37.5 cm). Maurice Sendak Collection, Rosenbach Museum & Library, Philadelphia

Various pieces of evidence have occasionally been offered to account for his choice of a new surname. The artist's brother, William, known as Kelly, had adopted the name Keats as early as 1945.[62] Lines from John Keats's poem *Endymion* were inscribed on a plaque at the entrance of Katz's high school and may have influenced his artistic sensibility.[63] (His brother's friend Louie had introduced him to the Romantic poetry of Percy Bysshe Shelley and John Keats even before Jack set foot in Thomas Jefferson High School.)[64] Less poetic and blunter is the report by the author Esther Hautzig, a friend of the artist, that "at Reader's Digest . . . he was advised that 'Keats would look better on the credits.'"[65] It is hard to ascertain whether this account is apocryphal or not. Most probably Keats started working on commissions for the magazine in the early 1950s, after he had changed his name, but he may have peddled his work there earlier. Fear of not being able to make a secure living

under his original Jewish last name may also have played a role, as it did for many others of his generation.

Keats wrote profusely, and often quite unflatteringly, about himself, but he remains silent in his autobiography about explaining the decision to Anglicize his name. Yet his notes often mention his having to face discrimination. Antisemitism, common before and after World War II, was often embedded in casual discourse. Keats remembered how one of his teachers tried to silence a class: "Quiet, you kids. . . . What do you think this is—a synagogue?"[66] Changing his name did not protect him from discriminatory remarks, however. In Paris in 1949, he was smitten by a young woman he met, only to be rudely woken from the spell when he heard her reaction at seeing an interracial couple: "Do you know that one Jew is as bad as ten blacks?" The artist was so shocked by the comment he could not bring himself to answer. Instead he parted from the woman, and later sent her a message: "I won't be meeting you tonight. I'll spare you further contamination. You see, I'm a member of one of those people your parents want to save you from—one of those Jews."[67] Keats's autobiography mentions his feelings of invisibility, his considering himself a second-class citizen, his not owning a passport as a young adult (he did not acquire one until he needed it to travel to Europe in 1949, and he did so under his new name), all seeming to explain his decision. The name change could be understood as emblematic of a desire by Jack Katz, the "invisible" Jewish kid from Brooklyn, to become more "visible," as an individual and as an artist. Alderson's observation that at the very time Keats changed his name he was also renewing his interest in art after a difficult hiatus seems to confirm that.[68]

One of Keats's most vivid recollections is his discovery of the Brooklyn Public Library when he was fourteen years old, during one of his long walks to try to rally his spirits.[69] His memories of perusing the shelves of art books for the very first time are deeply moving. It would take a while for him to learn that art history did not end with Impressionism, the last section in the library's art stacks, but his discovery of the library was transformative. Keats, who as a young boy lived in a world where "nobody seemed to know about [children's books]," found particularly poignant a return visit to the

branch when he was an adult. After descending the staircase that led to the old and familiar Reference Room, he encountered a parallel staircase leading to the Children's Room, where his own picture books could be found: "I stood looking at my own books on the shelves and mused at the wonder of it all," he wrote. "What long and winding paths had taken me from that staircase to this one?"[70] Keats's words clearly transmit his bewilderment at having been able to change the course

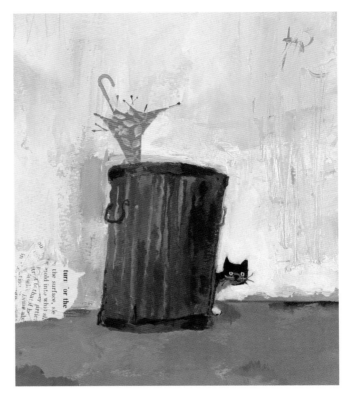

Fig. 19. Title page (detail). Final illustration for *Hi, Cat!* 1970. Paint and collage on board, 10 × 20 in. (24.5 × 50.8 cm)

of his own life and, through his art, to make the transition from the teenager in the background to a recognized children's book author and illustrator in the foreground of his field.

Fig. 20. A green string leads Louie to a surprise. Final illustration for *Louie,* 1975. Paint and collage on board, 10 × 19⅞ in. (25.4 × 50.5 cm)

For Alderson, it is in *Hi, Cat!* that "Keats achieves a marvelous balance of the qualities that give picture books their peculiar attraction. We are led into the story . . . past the garbage cans on the endpapers and past the first glimpse of that 'crazy cat' and the trashed umbrella on the title page."[71] But it is in the trashed umbrellas, the abandoned doors, the overflowing garbage cans, and the tattered-poster fences that Keats's poetry really lies (Figs. 19–21, Pl. 17). He makes the background elements sing, brings them to the foreground, and then rises above them. No wonder Alderson chose Keats's illustration of János the violinist from Myron Levoy's *Penny Tunes and Princesses* for the dust jacket of his wonderful monograph on the artist. What better embodiment of Keats's legacy than the vibrantly colored spread featuring a poor immigrant musician—a self-portrait of the invisible Jewish kid from Brooklyn—who, with the help of his art, manages to rise above the tenement rooftops, past the poverty, past the laundry lines, past those overflowing cans of trash (Fig. 22).

Fig. 21. Endpapers. Final illustration for *Pet Show!* 1972. Paint and collage on board, 9⅞ × 19⅞ in. (25.1 × 50.5 cm)

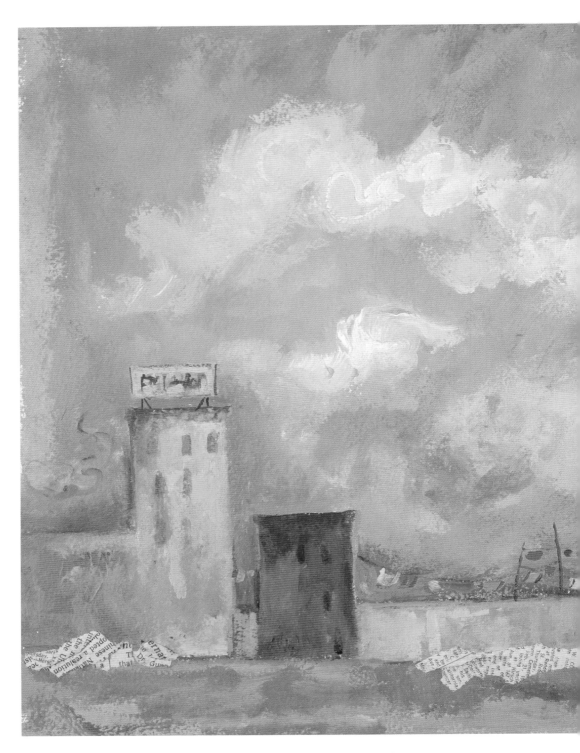

Fig. 22. Dust jacket. Final illustration for *Penny Tunes and Princesses,* by Myron Levoy, 1972. Paint and collage on board, 11½ × 20⅛ in. (29.2 × 51.1 cm)

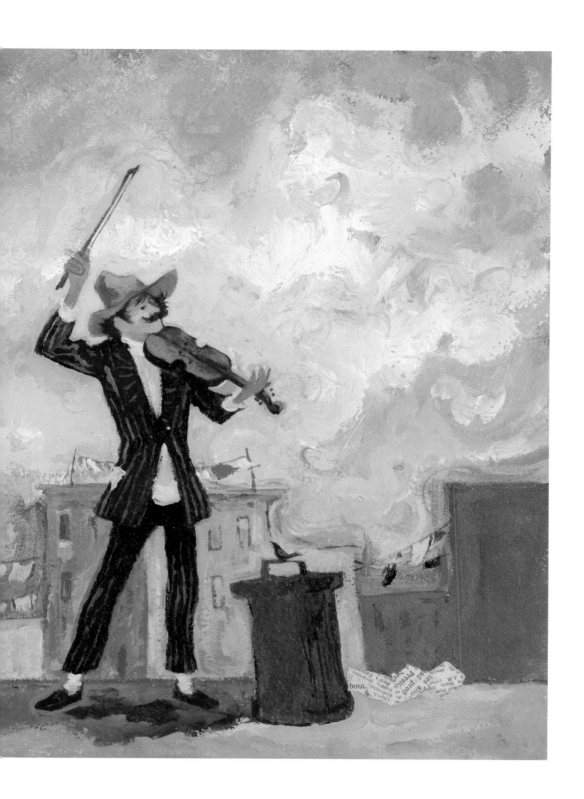

Notes

Epigraph: Quoted in Jay Williams, *A Change of Climate*, illustrated by Ezra Jack Keats (New York: Random House, 1956), p. 212.

1. "Pictures Worth Looking at Twice," *Times Literary Supplement*, November 3, 1972, p. 1326.

2. Brian Alderson, *Ezra Jack Keats: Artist and Picture-Book Maker* (Gretna, La.: Pelican, 1994), pp. 109, 138.

3. Ezra Jack Keats, "From COLLAGE: The Memoirs of Ezra Jack Keats," *The Lion and the Unicorn* 13, no. 2 (December 1989), p. 70.

4. Kathleen P. Hannah, "'Acknowledgment for What I Do, to Fortify Me to Go Ahead': Family, Ezra Jack Keats, and Peter," *Children's Literature Association Quarterly* 22, no. 4 (Winter 1997), p. 196. The episode was first cited in W. Nikola-Lisa, "The Image of the Child in the Picture Books of Ezra Jack Keats," in *The Image of the Child: Proceedings of the 1991 International Conference of the Children's Literature Association*, ed. Sylvia Patterson Iskander (Battle Creek, Mich.: Children's Literature Association), p. 22.

5. Ezra Jack Keats, unpublished autobiography, Ezra Jack Keats Papers, de Grummond Children's Literature Collection, McCain Library and Archives, University of Southern Mississippi (hereafter autobiography), box 70, folder 21, p. 6. During a taped interview with the artist conducted at Temple University in 1970, Keats mentioned that he was then working on an auto- biography for teenagers: "I have been talking to a tape for years." "Ezra Jack Keats, Author-Illustrator (1916–1983)," in Jaqueline Shachter Weiss, *Profiles in Children's Literature: Discussions with Authors, Artists, and Editors* (Lanham, Md.: Scarecrow, 2001), p. 173. Only a few excerpts of the extensive transcripts have been published, in Keats, "From COLLAGE," pp. 58–74.

6. Keats, autobiography, 75/2, p. 1. Also cited in Alderson, *Ezra Jack Keats*, p. 28, and in Martin Pope, "Ezra Jack Keats's Neigh- borhood," in *The Image of the Child: Proceedings of the 1991 International Con- ference of the Children's Literature Association*, ed. Sylvia Patterson Iskander (Battle Creek, Mich.: Children's Literature Associa- tion, 1991), p. 54.

7. Renée Gernand, "Enchanted by Realism," *New York Times Book Review*, January 19, 1986, p. BR21. The first use of this phrase in regard to Hopper was in a review of Gail Levin, *Hopper's Places* (New York: Alfred A. Knopf, 1985); the review is excerpted on the dust jacket of the second edition of the book (1998). Variations of the phrase appear in the press in connection with the exhi- bition *Edward Hopper*, a retrospective (co-organized by the Museum of Fine Arts, Boston, the National Gallery of Art, Washington, D.C., and the Art Institute of Chicago) that traveled in the United States in 2007 and 2008.

8. "I copied a Hopper, but I turned it into a black and white storm scene— terrible!" Keats wrote in his autobiography, 70/23, p. 19.

9. In his autobiography (71/23, p. 4), Keats speaks of his initial encounter with Daumier's work, during his first visit to the Metropolitan Museum of Art: "A very powerful feeling struck me in the chest, and filled my entire being. Drawn toward the painting, I left my father behind. Approaching it, I saw a picture of poor, gaunt travelers in a simple wooden railway train. I walked closer. The people became delineated. I stood riveted before it in a state of happiness I had never experienced. Such humble, weary, decent people pow- erfully and compassionately sculptured by the light from the window. . . . I looked at the frame and read: 'Third Class Carriage' by Honoré Daumier. I wanted to stand there forever."

10. As quoted in Donald Bratman's unpublished inter- view with Keats, "A City Block Is the World," pp. 2–3. Correspondence with Don- ald Bratman, n.d. Ezra Jack Keats Papers, de Grum- mond Children's Literature Collection, McCain Library and Archives, University of Southern Mississippi.

11. Keats, autobiography, 72/5, pp. 10–12.

12. Keats, autobiography, 70/2, p. 2. Also cited in a second version of the same story, 74/8, p. 1.

13. Keats, autobiography, 70/21, n.p.

14. Keats, autobiography, 70/2, p. 5.

15. Ibid., p. 2.

16. Keats, autobiography, 75/1, pp. 14–15.

17. Lynn Ellen Lacy was the first to ask whether Louie could be understood as a self-portrait of the artist. For her, the Louie books "demonstrate such subtle parallels with Keats's own life that one wonders if this poignant character is not the artist as a pain- fully sensitive child." Lynn Ellen Lacy, "Shape: *The Big Snow, White Snow Bright Snow,* and *The Snowy Day,*" in *Art and Design in Children's Picture Books: An Analysis of Caldecott Award–Winning Illustra- tions* (Chicago: American Library Association, 1986), p. 153.

18. Keats, autobiography, 70/23, p. 18.

19. Keats, autobiography, 71/13, p. 4.

20. Ibid.

21. Ibid., p. 27 (repagi- nated in Keats's hand, p. 3).

22. Review of *Louie, Winston-Salem Journal*, November 16, 1975.

23. *Captain Louie* was originally produced Off Broadway by Meridee Stein, Kurt Peterson, and Robert Reich. It was directed by Meridee Stein.

24. Alderson, *Ezra Jack Keats*, pp. 140, 132.

25. Claudia Cohl, "Keen on Keats," *Teacher* 92, no. 3 (November 1974), pp. 45–47.

26. Keats, autobiography, 70/2, p. 5.

27. Pope, "Ezra Jack Keats's Neighborhood," p. 54.

28. Keats, autobiography, 70/12, p. 10 (repaginated in Keats's hand, p. 15).

29. Keats, autobiography, 74/8, p. 4.

30. Pope, "Ezra Jack Keats's Neighborhood," p. 53.

31. Keats, autobiography, 70/12, p. 10 (repaginated in Keats's hand, p. 15).

32. Ibid., p. 11 (repaginated in Keats's hand, p. 16). In a second version of

this story, young Keats runs home before getting caught by Tzadik, and on another day, when he "got up enough courage to pass Tzadik's place again, I found a smooth piece of wood lying on his cellar door, and took it home," where he proceeded to paint on the board. Keats, autobiography, 74/8, p. 5.

33. Keats wrote a number of versions of this episode in his autobiography. In only one version did he note that he made his first original painting on the board left behind by Tzadik. Keats, autobiography, 70/20, p. 11 (repaginated in Keats's hand, p. 16).

34. Keats, autobiography, 70/12, pp. 11–12 (repaginated in Keats's hand, pp. 16–17).

35. The account of how Benjamin Katz, who worked as a waiter at a Greenwich Village diner, steadily furnished his young son with art supplies under the pretense that they had been given to him by starving artists in exchange for food has been frequently cited in the literature. Likewise the story of Jack's having to identify his father's body after he collapsed from a heart attack, and learning that the elder Katz had treasured in his wallet the announcements for the various art prizes his son had received. See Alderson, *Ezra Jack Keats*, p. 18.

36. Keats, autobiography, 74/8, p. 2.

37. Keats, autobiography, 70/28, pp. 4–5.

38. Keats, autobiography, 70/2, p. 3.

39. Keats, autobiography, 70/23, p. 19.

40. Reviews of *Louie* in *Publishers Weekly*, July 14, 1975, p. 60, and *The*

Christian Science Monitor, November 5, 1975.

41. Keats's choice of "Gussie" as the name for the puppet that is the object of Louie's affections strengthens the autobiographical nature of the story. This was the nickname of Keats's mother, Augusta Katz. That Louie is captivated by the inanimate Gussie could be understood as emblematic of the troubled relationship between Keats and his mother.

42. W. Nikola-Lisa, "Letters, Twigs, Hats, and Peter's Chair: Object Play in the Picture Books of Ezra Jack Keats," *Children's Literature Association Quarterly* 16, no. 4 (Winter 1991), p. 257.

43. Ibid., p. 258.

44. Ibid., p. 255.

45. Alderson, *Ezra Jack Keats*, pp. 63, 147.

46. Ezra Jack Keats, "Where Do Ideas Come From?" (unpublished paper), Ezra Jack Keats Papers, de Grummond Children's Literature Collection, McCain Library and Archives, University of Southern Mississippi, 87/1, p. 1. Keats initially drafted the story in first person; dummy book for *Apt. 3*, Ezra Jack Keats Papers, 1/6. Alderson reports that in an interview Keats further identified the piece of music as Tchaikovsky's *1812 Overture*. Alderson, *Ezra Jack Keats*, pp. 136, 216n.8.

47. Alderson, *Ezra Jack Keats*, p. 111.

48. Correspondence with Spencer Shaw, July 25, 1971, Ezra Jack Keats Papers, de Grummond Children's Literature Collection, McCain Library and Archives, University of Southern Mississippi, cited

in Alderson, *Ezra Jack Keats*, p. 138.

49. Keats's correspondence with Singer is in the Ezra Jack Keats Papers, de Grummond Children's Literature Collection, McCain Library and Archives, University of Southern Mississippi.

50. Keats, "Where Do Ideas Come From?" p. 6. As stressed by Alderson, Keats's intention in *Apt. 3* was clearly missed by one reviewer, who understood the book's ending as a decrescendo. For more on the book's critical reception, see Alderson, *Ezra Jack Keats*, pp. 180–181.

51. Alderson, *Ezra Jack Keats*, p. 138.

52. Ibid., p. 146.

53. Keats, autobiography, 74/13, p. 3.

54. Alderson, *Ezra Jack Keats*, pp. 136–137.

55. Keats's recollections are recorded in his autobiography, 74/8, pp. 7–8.

56. Keats, autobiography, 73/16, pp. 12–13, 16–17, and 73/20, p. 2.

57. Cited in Bratman, "A City Block Is the World," p. 3.

58. It should be noted that Brian Alderson wrote a review of *We Are All in the Dumps with Jack and Guy* (*New York Times Book Review*, November 14, 1993, p. 17).

59. His meeting Martin Pope at the age of fourteen transformed Keats's life for the better. For Keats and Pope's lifelong and moving friendship, see "A Memoir by Martin Pope," published in Alderson, *Ezra Jack Keats*, chap. 2, pp. 67–74.

60. Kathleen Hannah dwells on this point in "'Acknowledgment for What I Do, to Fortify Me to Go Ahead,'" p. 202.

61. Keats, autobiography, 71/13, p. 26 (repaginated in Keats's hand, p. 2).

62. AAF (Army Air Force) Personal Affairs statement, July 11, 1945, Ezra Jack Keats Papers, de Grummond Children's Literature Collection, McCain Library and Archives, University of Southern Mississippi, 78/12, cited in Alderson, *Ezra Jack Keats*, p. 34.

63. As reported by Alderson, *Ezra Jack Keats*, pp. 21–22.

64. Keats, autobiography, 74/14, p. 1.

65. Cited in Pat Cummings, "The Man Who Became Keats," *School Library Journal* 47, no. 5 (May 1, 2001), p. 48.

66. Keats, autobiography, 71/13, p. 14 (repaginated in Keats's hand, p. 8).

67. Keats, autobiography, 72/8, pp. 29–34.

68. Alderson, *Ezra Jack Keats*, p. 34.

69. Ezra Jack Keats, "Ezra Jack Keats Remembers: Discovering the Library," *Teacher* 94, no. 4 (December 1976), pp. 40–41.

70. Ibid., p. 41.

71. Alderson, *Ezra Jack Keats*, p. 147.

One
Small
Step

Maurice Berger

The world changes according to the way people see it, and
if you alter, even by a millimeter, the way . . . people look at
reality, then you can change it.

— *James Baldwin*

In 1962, Ezra Jack Keats's *The Snowy Day* was published by
Viking Press (Fig. 23). The first full-color picture book to fea-
ture an African-American protagonist, the work represented
a landmark in mainstream children's literature. Through innovative
collage techniques and poetic language, *The Snowy Day* told the
story of Peter, an inner-city boy encountering his first snowfall. The
book—acclaimed in its time, garnering praise from literary critics
and cultural leaders—established Keats as one of the era's foremost
children's authors. The positive reception owed much to the state of
race relations in the early 1960s. As the modern civil rights move-
ment was in full swing—the federal courts were systematically
dismantling *de jure* segregation, and historic protests and boycotts
were foregrounding the problem of racism in America—Keats's book
was received with enthusiasm by many progressive educators, librar-
ians, and parents, black and white. Less than a year after it was
published, the Association for Library Service to Children, a division
of the American Library Association, awarded the book its highest
honor, the Caldecott Medal.

Keats's intention in writing *The Snowy Day* was unambigu-
ously social: he wanted the book to "lead all children to genuine
self-acceptance."[1] The story of Peter—the subject of seven picture
books Keats published between 1962 and 1972—was inspired by
the author's own difficult childhood in Brooklyn.[2] He was the son of
Polish Jewish immigrants, and his early life, beset by poverty and
antisemitism, made him empathetic to "children of different races
and backgrounds, who had suffered as he had."[3] In mid-twentieth-
century mainstream children's literature, however, black characters
rarely appeared. When they did, they usually embodied negative
stereotypes. Keats had illustrated more than thirty books by other
writers between 1954 and 1962, none of which had a black protag-

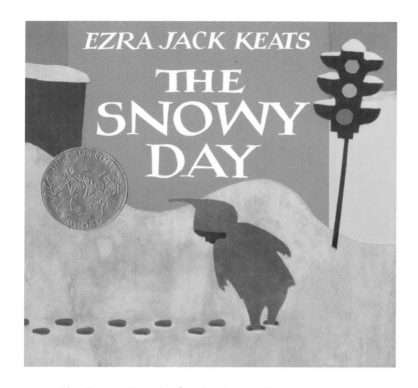

onist. *The Snowy Day*, the first book both illustrated and written by Keats, afforded him an opportunity to help correct a problem with children's literature that had long troubled him: black invisibility.[4]

The necessity of Keats's project cannot be overstated. Despite the inroads of the modern struggle for racial equality and justice, mainstream culture in the early 1960s remained a relatively hostile environment for African-American children. Media geared to young people, including books, magazines, television, and film, proffered an image of an almost exclusively white America. When black people were depicted, they were most often represented as regressive and stereotypical—fools, clowns, servants, and dim-witted boys and girls meant to entertain white people and play to their prejudices. As early as the 1940s, the African-American psychologist Dr. Kenneth Clark examined the deleterious effects of cultural invisibility and stereotypes on black children. Showing African-American grade school students separate drawings of dolls, identical in every way except skin color, he asked them individually to point out the doll they liked "best" and would "like to play with," as well as which doll was "nice" and which one was "bad." The youngsters were also

asked to determine the race of the dolls and select the one that they believed looked most like them. While the children easily identified the dolls' race, as well as their own, ten out of sixteen preferred the white doll and considered it "nice," while eleven saw the black doll as "bad." The study confirmed the extent to which black children readily internalized the disapproving image of their race then prevalent in all aspects of public life, a problem that resulted in poor self-esteem, feelings of inferiority, confused self-image, hostility, and resentment.[5]

Educators, intellectuals, and critics were largely supportive of The Snowy Day. A figure no less esteemed than Langston Hughes, for example, whose books for children proffered strong and positive African-American imagery, proclaimed Keats's work "perfectly charming," and lamented that he did not have "grandchildren to give it to."[6] Nevertheless, others were critical of The Snowy Day. Ray Anthony Shepard argued that aside from Peter's brown skin—and that of his mother—the issue of race, as well as the story of African-American history and culture, was fundamentally irrelevant to the book. In particular, Shepard was skeptical of what he believed was Keats's attempt to humanize and normalize a black child by depicting him as racially neutral, enjoying "snow and whiteness as well as everyone else."[7] Asserting that The Snowy Day espoused the white liberal orthodoxy of its time—especially the expectation that in "order for there to be equality, there must be similarity"—Shepard concluded that the book did little to celebrate cultural difference, instill racial pride in black children, or challenge the supremacy of white readers.[8]

Shepard's criticism is not entirely unreasonable. Keats himself had expressed a desire to represent experiences that "all people share."[9] While acknowledging that there were some "experiences unique to each ethnic group" and others that were "common to all of us," he observed that "the universal experience" was his principal concern.[10] In most of Keats's stories, children engage typical problems and situations unrelated to race or ethnicity, such as sibling rivalry or learning how to whistle—"a day in the life of a little boy who happens to be brown," as one review of The Snowy Day put it.[11] Embracing the white liberal ideal of color blindness, and thus avoiding the question of race altogether, many reviewers made no

mention of Peter's race—an omission that obscured one of Keats's most significant contributions to children's literature.[12]

The problem with Shepard's criticism of *The Snowy Day*, however, was that it did not acknowledge the urgent need to reform mainstream culture, and, as Clark's study suggested, its proclivity for black invisibility and stereotypes. Then as now, the self-image of children and their understanding of one another, regardless of their race or ethnicity, were shaped to a considerable degree by mainstream media that infiltrated all aspects of American life. While racially specific art, music, theater, and literature could instill pride and improve self-esteem in black children, a segregated and white-identified mainstream culture would continue to injure them by broadly affirming the superiority and normative status of whiteness and the inferiority of blackness. Just as important, the introduction of positive black imagery into everyday life would also help alter white children's hierarchical image of themselves in relation to others, an important step in the process of undoing prejudice.

In the early 1960s, more than twenty years before the idea of multiculturalism began to take hold in the arts and education, most young people were not exposed to African-American children's literature or to racially specific stories about black people, even in integrated urban classrooms and libraries. The work that Shepard, writing in 1971, cites as an exemplary and widely read Afrocentric children's book, *Stevie,* by the black author John Steptoe, was not published until 1969. Thus, while Shepard astutely understood the limitations of white liberalism, he failed to recognize the extent to which *The Snowy Day*, despite its association of equality with similarity, challenged the negligence—and destructiveness, as Clark's research confirmed—of a children's publishing industry that all but banished positive representations of black people. As a tentative Peter stepped out into his first snowfall, confronting the relentless whiteness of his urban environment, his journey served as a metaphor of Keats's own imperative to introduce blackness into a cultural milieu that saw little reason to include it. The odds against Keats were considerable. Only a few years earlier, the author Helen Kay had been forced by the marketing department of her publisher, Hastings House, to transform the black protagonist of her book *A Sum-*

mer to Share (1960)—about a "Negro child from the city who visits a white family in the country on a Fresh Air Fund vacation"—into a poor white child.[13]

Breaking through the glass ceiling of color in the children's book industry, though it was a significant achievement, was not the only reason *The Snowy Day* mattered in the cultural politics of American race relations.

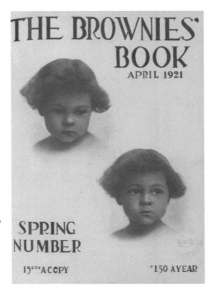

Fig. 24. Cover of *The Brownies' Book,* April 1921

The "first twentieth-century milestone in African American children's literature," *The Brownies' Book*, provides insights into Keats's achievement.[14] Issued from 1920 through 1921, this was, in fact, a magazine, coedited by the great black intellectual and activist W. E. B. Du Bois, one of the founders of the National Association for the Advancement of Colored People (Fig. 24). Du Bois advocated for excellence in African-American education, including rigorous instruction in reading, writing, science, and the arts. The purpose of *The Brownies' Book*—a monthly anthology of fiction, poems, world and national news, illustrations, photographs, and stories about exemplary black children—was to "lift the veil of invisibility and counteract false images and stereotypes in children's books and magazines."[15]

In his proposal for *The Brownies' Book*, Du Bois listed seven objectives. Several goals—familiarizing children with "the history and achievement of the Negro race," for example, or inspiring them to "prepare for definite occupations and duties"—would appear to have little relationship to *The Snowy Day*.[16] Two objectives, however, were central to Keats's book: helping black children to "realize that being 'colored' is a normal, beautiful thing," and turning their "hurts and resentments into emulation, ambition, and love of their home and companions."[17]

By countermanding the conventional representation of happy and well-adjusted children who are exclusively white, *The Snowy*

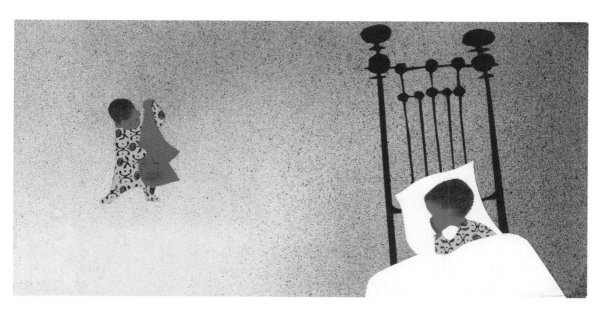

Day fulfilled what Du Bois believed was the most important role of children's literature: encouraging black youngsters to see themselves as normal and content. But it is Peter's handling of his sadness and disappointment that may well represent the book's most important correspondence with *The Brownies' Book*. In the story, the child wakes to his first snowfall. After breakfast, he puts on his snowsuit and ventures outside. As he frolics in the cold air, the snow crunching beneath his feet, he encounters older boys in a snow fight, but avoids them because he is too young and might get hurt. Peter builds a snowman, then an angel. Done with play, he gathers up a snowball and takes it home with him as a keepsake of his momentous day. When he attempts to retrieve the snowball from his coat pocket later that night, it is gone, and he is distraught (Fig. 25). At the story's end, he goes "to sleep in sorrow, [but] wakes to the joy of another snowy day" (Fig. 26).[18]

Fig. 25. "Before he got into bed he looked in his pocket." Final illustration for *The Snowy Day,* 1962. Collage, paint, ink, and pencil on board, 10⅝ × 20⅝ in. (26.6 × 52.4 cm)

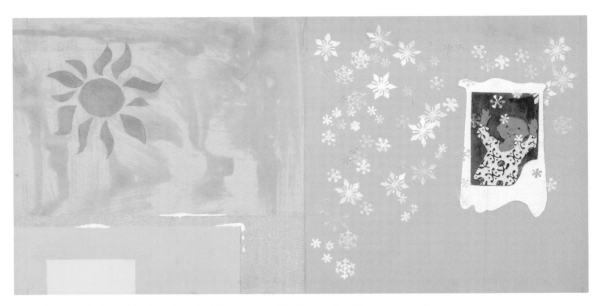

Fig. 26. ". . . he dreamed that the sun had melted all the snow away. But when he woke up his dream was gone."
Final illustration for *The Snowy Day,* 1962. Collage, paint, and pencil on board, 9⅞ × 19⅞ in. (25.1 × 50.5 cm)

As the British educator and scholar Bob Dixon observes, snow
in Keats's story is a symbol of a "white world that black people can
enter into, integrate with, with success and enjoyment."[19] While
Keats's symbolism privileges whiteness, rendering it the focus of
a black child's aspirations, as Dixon critically notes, it also speaks
to the reality of a cold and brutal society that, by virtue of its rac-
ism and majority status, has the power to wound and deprive black
children. That *The Snowy Day* allegorizes an African-American boy's
triumph over a potentially challenging world—his ability to turn his
hurt into contentment and happiness, as Du Bois might say—was
made abundantly clear by Keats's original jacket art, an image that
was rejected by his editor at Viking.[20] In the published version, Peter
looks back on his tracks in the snow. In the original, the boy leans
defiantly against a gigantic snowman, symbolizing his ability to man-
age, and even take control of, an imposing whiteness, an idea made
explicit by the snowman's looming human countenance (Fig. 27).

The historical record suggests that Keats did not conceive the protagonist of *The Snowy Day* as racially neutral: "I wanted to make sure I didn't make Peter a white kid colored brown," he later observed.[21] In his acceptance speech for the Caldecott Medal, the author revealed his inspiration for the character: "four candid photos of a little boy," published in *Life* magazine in May 1940 (Fig. 28).[22] Keats was captivated by the child's "expressive face, his body attitudes, the very way he wore his clothes."[23] What Keats did not mention at the time was the context of the photograph: the African-American child depicted, frightened by the blood test he was about to have, was the subject of a "malaria survey" in Liberty County, Georgia. At the height of the Great Depression, deadly malaria outbreaks had erupted in the South, disproportionately affecting poor African-Americans. Thus, the model for Peter, rather than simply a cute and expressive boy, was an imperiled black child—one who would go on, in Keats's vivid imagination, to survive and flourish.

It is not surprising, then, that *The Snowy Day* was a source of hope and encouragement for many: the teacher who, after reading

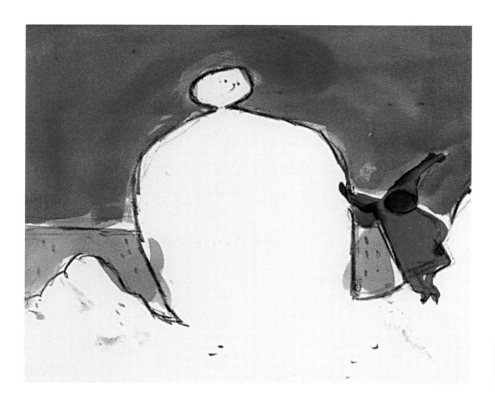

Fig. 27. Rejected preliminary sketch for the cover of *The Snowy Day,* 1962.

it and showing the illustrations to her class, observed that African-American students started using brown paint, instead of pink, when making pictures of themselves, and the librarian who reported that it was a "prime favorite" of black mothers, children, and teachers. There is perhaps no greater testimony to the power of Keats's work to change the lives of its young readers than that of the venerated American Indian writer Sherman Alexie, who credits *The Snowy Day* with transforming him from a casual to a voracious reader. "I vividly remember the first day I pulled that book off the shelf," he writes. "It was the first time I looked at a book and saw a brown, black, beige character—a character who resembled me physically and spiritually, in all his gorgeous loneliness and splendid isolation."[24]

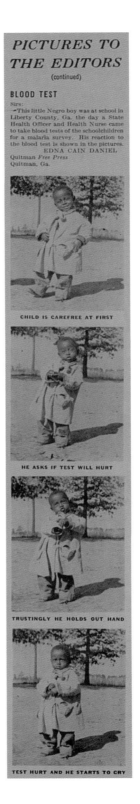

Fig. 28. "Pictures to the Editors" clipping that inspired the character Peter in *The Snowy Day,* from *Life* magazine, May 13, 1940

Notes

Epigraph: James Baldwin, interview with Mel Watkins, *New York Times Book Review*, September 23, 1979, p. 3.

1. Ann McGovern, "An Afternoon with Ezra Jack Keats," *See-Saw Books Newspaper*, January–February 1967, p. 8S.

2. Keats's books featuring the character of Peter are: *The Snowy Day* (1962), *Whistle for Willie* (1964), *Peter's Chair* (1967), *A Letter to Amy* (1968), *Goggles!* (1969), *Hi, Cat!* (1970), and *Pet Show!* (1972). For a general biography of Keats, see Brian Alderson, *Ezra Jack Keats: Artist and Picture-Book Maker* (Gretna, La.: Pelican, 1994), pp. 15–66.

3. Anita Silvey, "Introduction," in *Keats's Neighborhood: An Ezra Jack Keats Treasury* (New York: Viking, 2002), p. 7.

4. Keats later observed: "I decided that if I ever did a book of my own . . . my hero would be a Black child. I wanted him to be in the book on his own, not through the benevolence of white children or anyone else." "Ezra Jack Keats, 1916–1983," *Children's Literature Review* 35 (February 1995), p. 83.

5. Kenneth B. Clark, "How Children Learn About Race," in *Prejudice and Your Child* (Middletown, Conn.: Wesleyan University Press, 1988), pp. 19–22.

6. Langston Hughes, letter to Ezra Jack Keats, February 18, 1963, correspondence file, Ezra Jack Keats Papers, de Grummond Children's Literature Collection, McCain Library and Archives, University of Southern Mississippi.

7. Ray Anthony Shepard, "Adventures in Blackland with Keats and Steptoe," *Interracial Books for Children Bulletin* 3, no. 4 (1971), p. 3.

8. Ibid. Shepard continues: "[Keats's] books may serve a necessary function for those people who need to be convinced of our human similarity, and who cannot give up the melting pot myth. The white reader, if I may engage in the dangers of generalization, will see in Keats's characters children who confirm sameness, but who live in a terrible environment. The reader's emotional response combines a feeling of pity and an attraction to the children's adventures. Thus is created another generation of liberals."

9. Keats, in "Ezra Jack Keats, 1916–1983," p. 84.

10. Ibid. For another critical reading of *The Snowy Day*, see Nancy Larrick, "The All-White World of Children's Books," *Saturday Review*, September 11, 1965; reprinted in Osayimwense Osa, ed., *The All White World of Children's Books and African American Children's Literature* (Trenton, N.J.: Africa World Press, 1995), p. 5.

11. Alice Dalgliesh, "In All of Our Daily Lives," *Saturday Review*, July 20, 1963, p. 33.

12. See, for example, George A. Woods, "In the Hour Between the Dark and the Daytime Comes a Pause for the Picture Book," *New York Times Book Review*, November 11, 1962, pp. 36–37; Polly Goodwin, "The Junior Bookshelf," *Chicago Daily Tribune*, December 9, 1962, p. E14; Claudia Royal, "Small Boy's Adventures in Snow Prove Delightful," undated clipping from *Marin Independent Journal*, Ezra Jack Keats Papers, de Grummond Children's Literature Collection. The most explicit erasure of Peter's race as a self-congratulatory indication of racial tolerance appears in John Rowe Townsend, "The Other America," *The Guardian*, February 6, 1970, p. 9: "Penny, our youngest, first saw *The Snowy Day* when she was six and didn't notice that Peter wasn't white, though it jumps out at an adult reader. This I feel must prove something about something."

13. See Larrick, "The All-White World of Children's Books," p. 7.

14. Rudine Sims Bishop, *Free Within Ourselves: The Development of African American Children's Literature* (Santa Barbara, Calif.: Greenwood, 2007), p. 21.

15. Ibid., 24. For reproductions of stories, columns, and illustrations from *The Brownies' Book*, see Dianne Johnson-Feelings, ed., *The Best of The Brownies' Book* (Oxford: Oxford University Press, 1996).

16. One work by Keats, published three years after *The Snowy Day*, would appear to embrace these goals: *John Henry: An American Legend* (New York: Pantheon, 1965). The picture book tells the story of John Henry, a mighty black railroad worker, subject of numerous songs and stories, whose strength, perseverance, and bravery were legendary. Although the character was thought to be mythic, Keats believed he had actually lived, based on accounts he uncovered about a young African-American worker with the Chesapeake and Ohio Railway who challenged the newly invented steam drill while working on the Big Bend Tunnel in West Virginia around 1870.

17. For more on Du Bois's objectives, see Bishop, *Free Within Ourselves*, pp. 23–25.

18. Alice Dalgliesh, "Stories for the Christmas Season," *Saturday Review*, December 15, 1962, p. 27.

19. Bob Dixon, "Racism: All Things White and Beautiful," in *Catching Them Young*, vol. 1: *Sex, Race, and Class in Children's Fiction* (London: Pluto, 1977); reprinted in "Ezra Jack Keats, 1916–1983," p. 93.

20. See Silvey, "Introduction," p. 8.

21. Keats, as quoted in Margo Huston, "Honesty Is the Author's Policy for Children's Books," *Milwaukee Journal*, March 28, 1974, part 2, p. 6.

22. Edna Cain Daniel, letter to the editor, *Life*, May 13, 1940, as quoted in Alderson, *Ezra Jack Keats*, p. 51.

23. Ezra Jack Keats, "Caldecott Award Acceptance," speech given at American Library Association meeting, Chicago, July 15, 1963; printed in *The Horn Book Magazine* 39, no. 4 (August 1963), p. 361.

24. These accounts appear, respectively, in McGovern, "An Afternoon with Ezra Jack Keats," pp. 8S, 11S; Dorothy Busby, letter to the editor, *Saturday Review*, October 2, 1965, n.p.; Sherman Alexie, "People Might Want to Listen to Me, Too," in *Everything I Need to Know I Learned from a Children's Book*, ed. Anita Silvey (New Milford, Conn.: Roaring Book, 2009), p. 177.

The Art of Ezra Jack Keats

Plate I *Shantytown*, c. 1934. Oil on canvas, 18⅝ × 23⅞ in. (47.3 × 60.6 cm)

Plate 2 "Crunch, crunch, crunch, his feet sank into the snow." Final illustration for *The Snowy Day,* 1962. Collage and paint on board, 9 × 20 in. (22.9 × 50.8 cm)

Plate 3 "And he thought and thought and thought about them." Final illustration for *The Snowy Day,* 1962. Collage and pencil on board, 9⅞ × 19⅞ in. (25.1 × 50.5 cm)

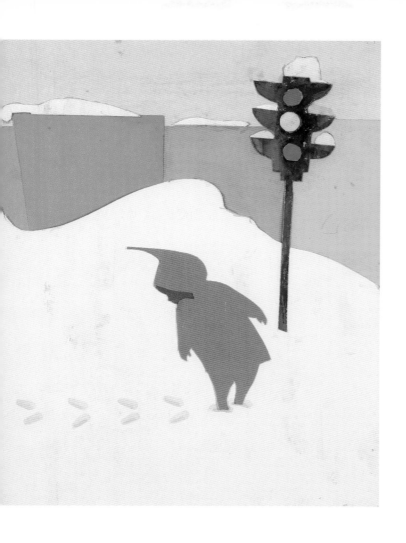

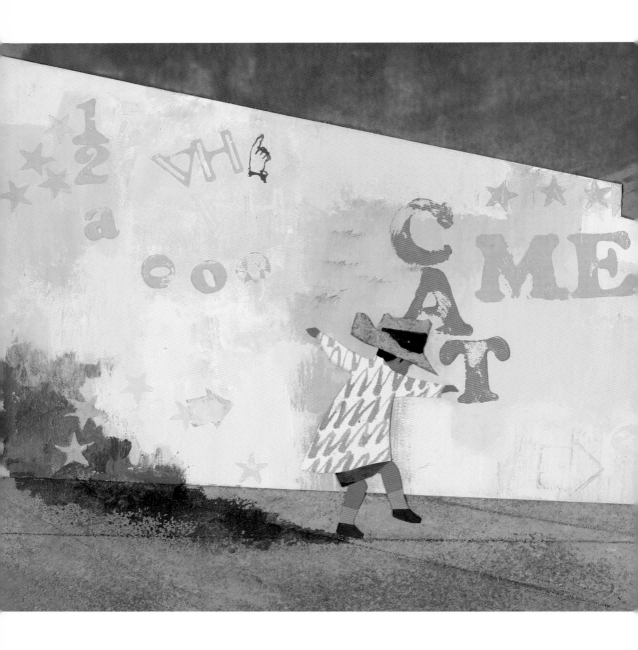

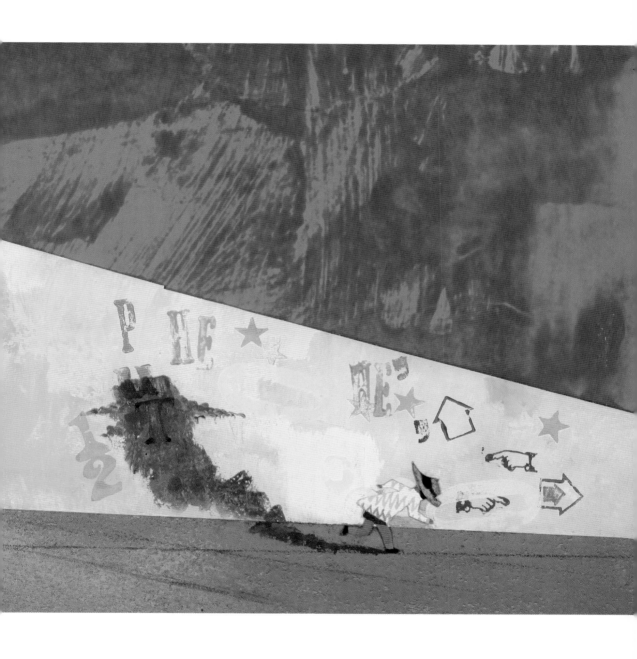

Plate 4 "First he walked along a crack in the sidewalk." Final illustration for *Whistle for Willie*, 1964. Collage and paint on board, 10 × 20⅛ in. (25.4 × 51.1 cm)

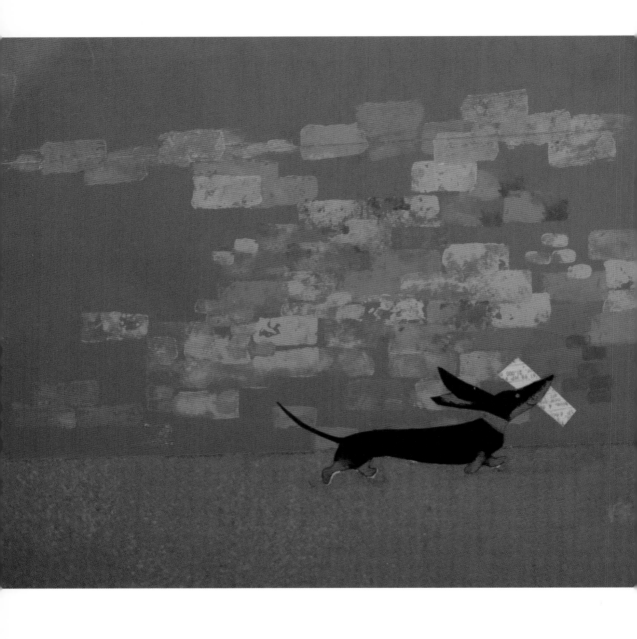

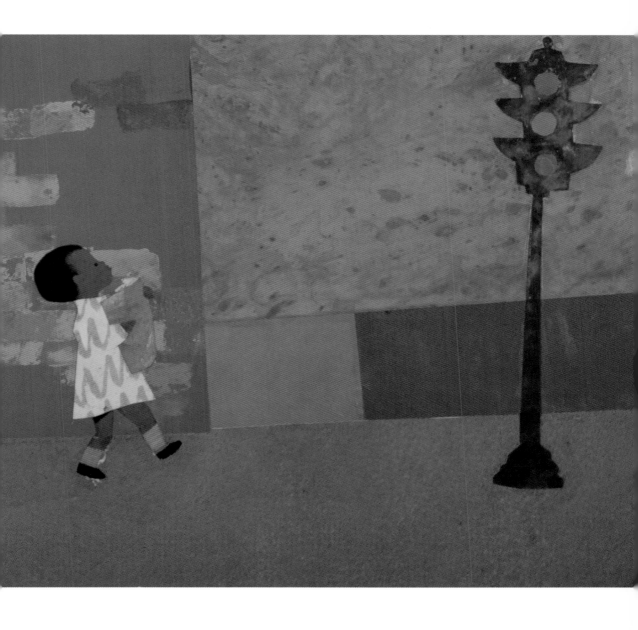

Plate 5 "Peter's mother asked him and Willie to go on an errand to the grocery store." Final illustration for *Whistle for Willie*, 1964. Collage and paint on board, 9¾ × 19⅞ in. (24.8 × 50.5 cm)

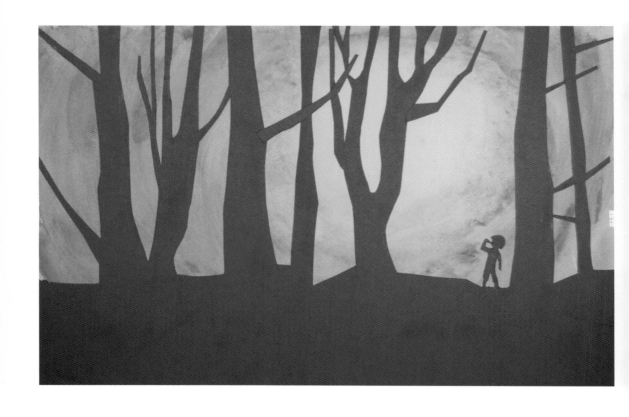

Plate 6 "But all he saw in the woods was the sun shining . . ." Final illustration
for *Zoo, Where Are You?* by Ann McGovern, 1964. Collage and paint on board,
12½ × 17⅞ in. (31.7 × 45.4 cm)

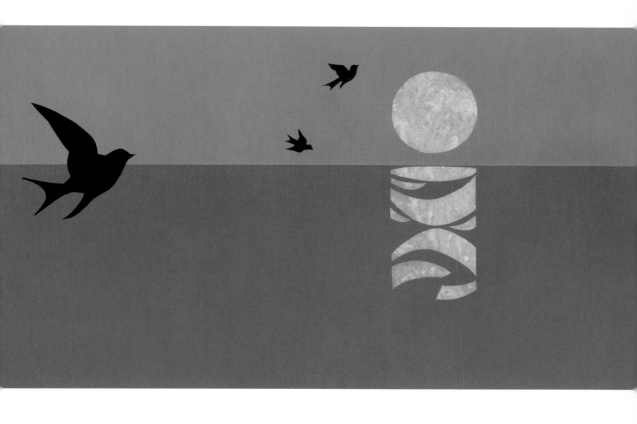

Plate 7 Dust jacket. Final illustration for *In a Spring Garden,*
edited by Richard Lewis, 1965. Collage on board, 12⅝ ×
22½ in. (32.1 × 57.1 cm)

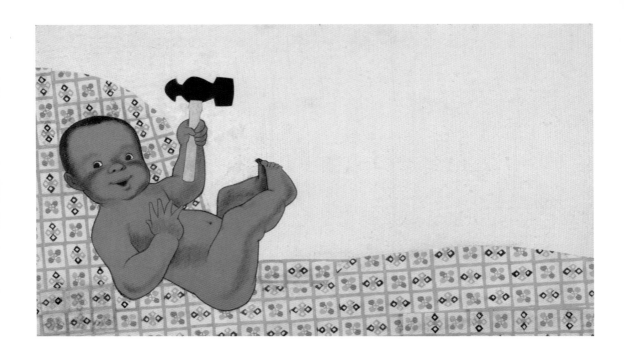

Plate 8 "And John Henry was born, born with a hammer in his hand!"
Final illustration for *John Henry: An American Legend,* 1965. Collage,
paint, and pencil on board, 13⅛ × 20⅝ in. (33.3 × 52.4 cm)

Plate 9 "'Oooh, I'm hurt bad,' he groaned. 'I can't get up.'" Final
illustration for *John Henry: An American Legend,* 1965. Paint, pencil,
and collage on board, 13 × 20½ in. (33 × 52.1 cm)

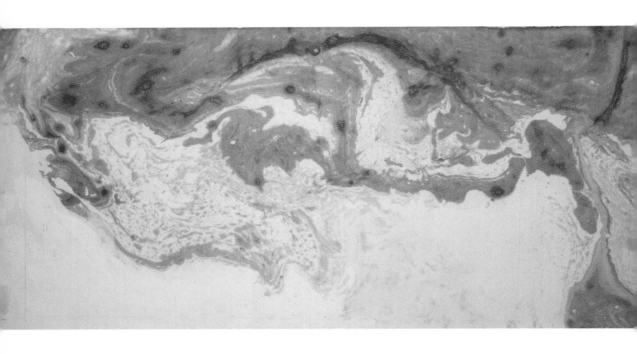

Plate 10 "The heavens declare the glory of God . . . (Judaism)" (Psalm 19:2).
Final illustration for *God Is in the Mountain*, 1966. Paint on marbleized paper,
mounted on board, 10 × 20 in. (25.4 × 50.1 cm)

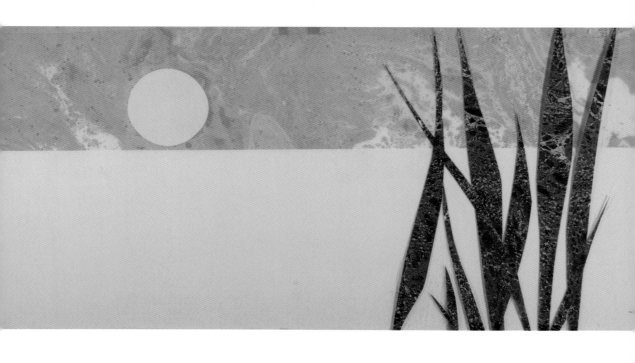

Plate 11 ". . . weave for us a garment of brightness (American Indian, Tewa Pueblo)." Final illustration for *God Is in the Mountain,* 1966. Collage on board, 10 × 20 in. (25.4 × 50.1 cm)

Plate 12 "They added a picture of swans . . . leaves . . . and some paper flowers."
Final illustration for *Jennie's Hat*, 1966. Collage and paint on paper, 10 × 20 in.
(25.4 × 50.1 cm)

Plate 13 "They went outside and stood in front of his house." Final illustration for
Peter's Chair, 1967. Paint and collage on board, 9⅞ × 20 in. (25.1 × 50.1 cm)

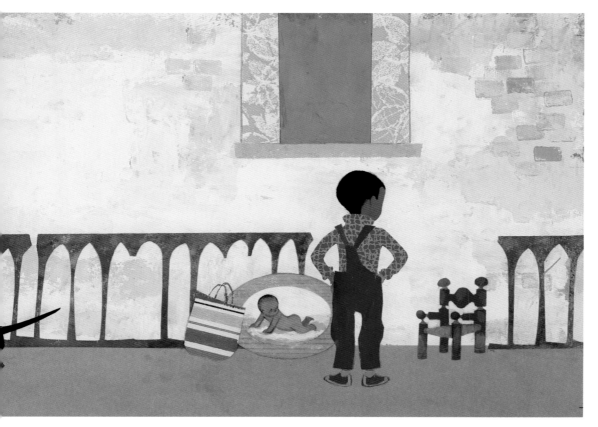

Plate 14 "Walking to the mailbox, Peter looked at the sky." Final illustration for *A Letter to Amy*, 1968. Collage, watercolor, paint, and crayon on board, 9½ × 19¾ in. (24.1 × 50.2 cm)

Plate 15 "In his great hurry, Peter bumped into Amy." Final illustration for *A Letter to Amy*, 1968. Watercolor, paint, and collage on board, 10 × 19¾ in. (25.4 × 50.2 cm)

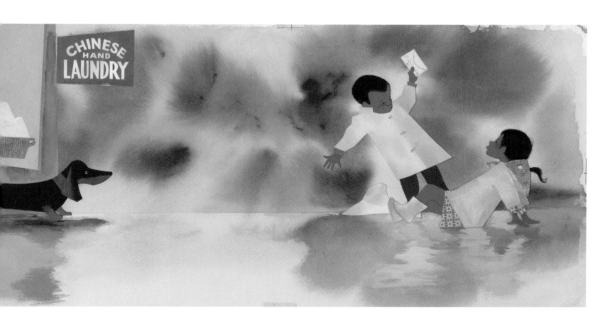

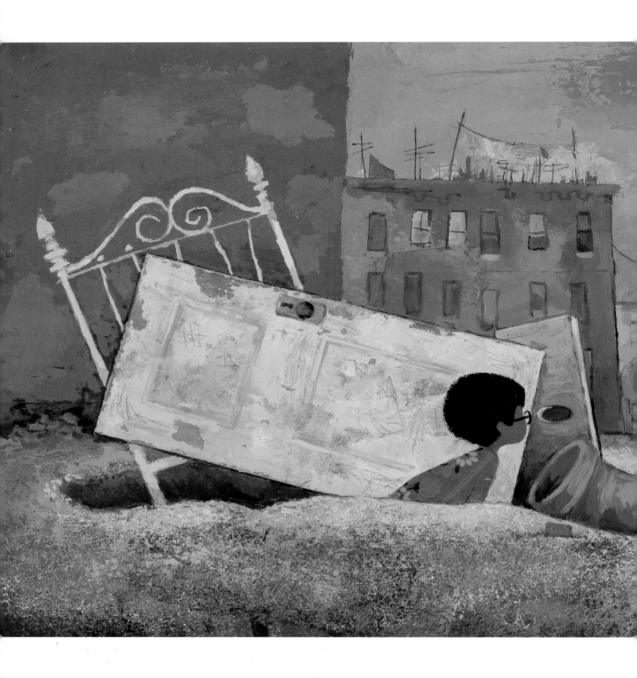

Plate 16 "Archie, look what I found,' Peter shouted through the pipe." Final illustration
for *Goggles!* 1969. Paint and collage on board, 10 × 20 in. (25.4 × 50.1 cm)

Plate 17 "Peter, Archie and Willie crept out of the hideout." Final illustration for
Goggles! 1969. Paint and collage on board, 10 × 19⅞ in. (25.4 × 50.5 cm)

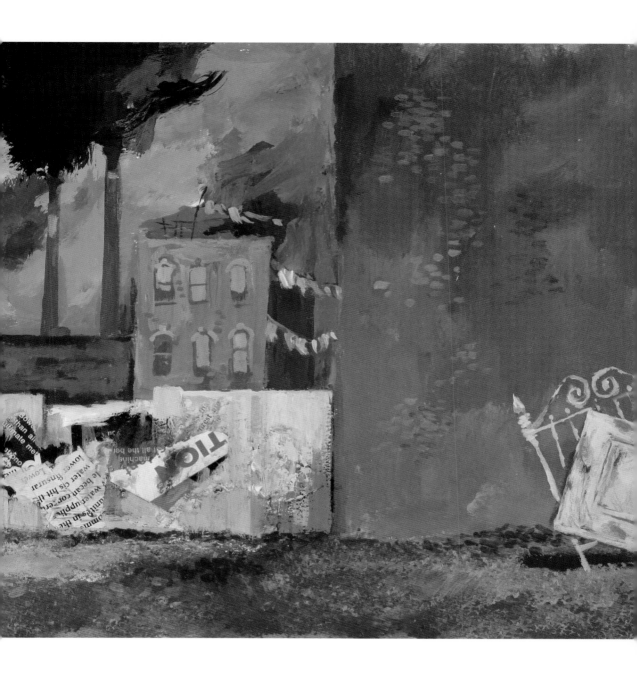

Plate 18 Dust jacket. Final
illustration for *Hi, Cat!* 1970. Paint
and collage on board, 11 × 22 in.
(27.9 × 55.9 cm)

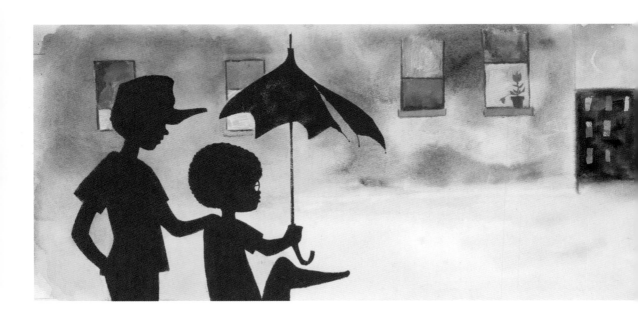

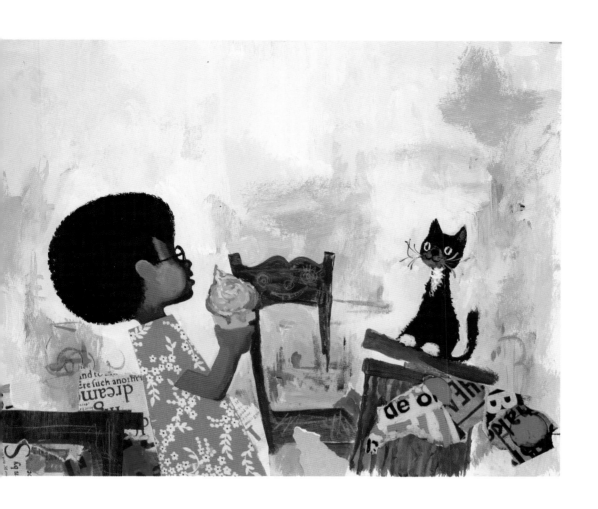

Plate 19 "'It would have been great if it wasn't for that crazy cat,' said Peter as they walked home." Final illustration for *Hi, Cat!* 1970. Watercolor, paint, and pastel on board, 11 × 2⅞ in. (27.9 × 55.6 cm)

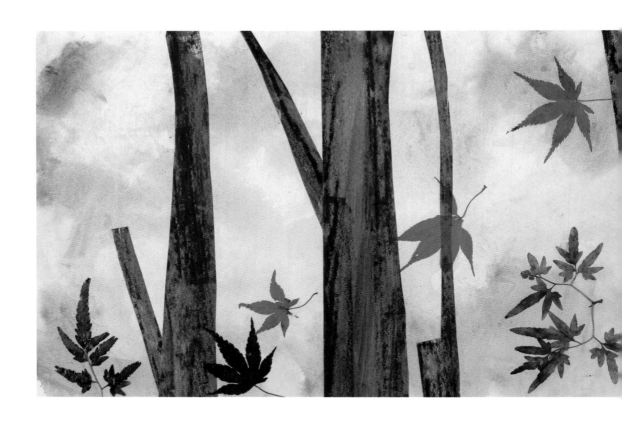

Plate 20 Endpapers. Final illustration for *Over in the Meadow,* by Olive A. Wadsworth, 1971. Collage and watercolor on board, 9½ × 20 in. (24.1 × 50.1 cm)

Plate 21 ". . . in a soft shady glen, lived a mother firefly and her little flies ten."
Final illustration for *Over in the Meadow,* by Olive A. Wadsworth, 1971. Collage and paint on marbleized paper, mounted on board, 9½ × 20 in. (24.1 × 50.1 cm)

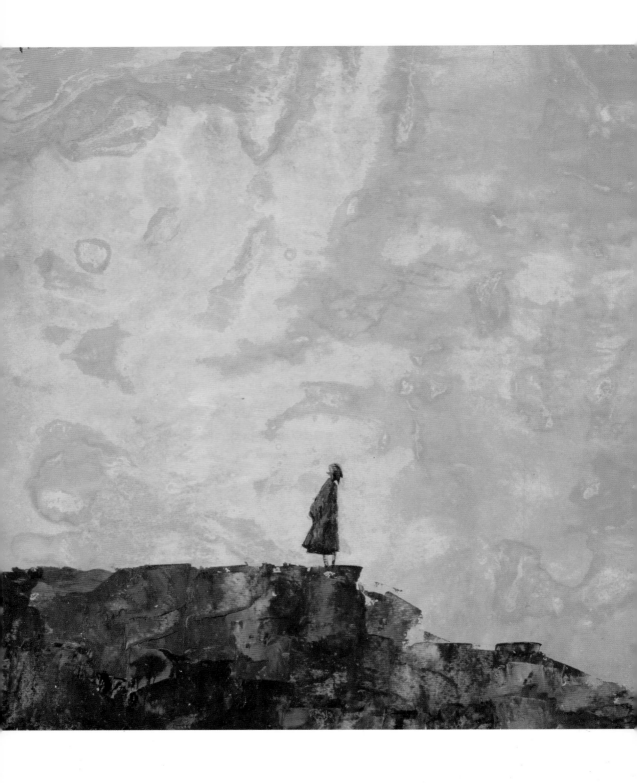

Plate 22 "Finally, he reached the King's high palace." Final illustration for *The King's Fountain,* by Lloyd Alexander, 1971. Paint on marbleized paper, mounted on board, 12¼ × 23 in. (31.1 × 58.4 cm)

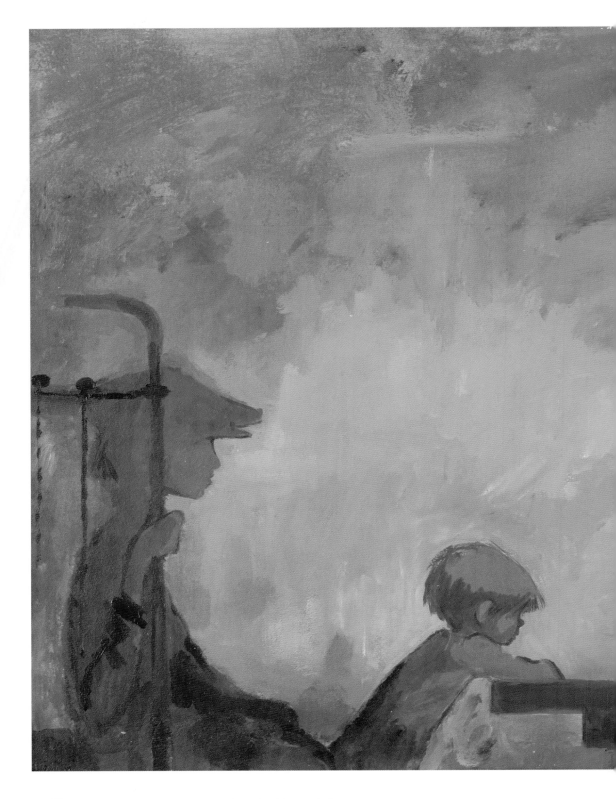

Plate 23 "He stood up suddenly, raised his harmonica to his mouth, and began to play."
Final illustration for *Apt. 3*, 1971. Paint on board, 17 × 22¾ in. (43.2 × 57.8 cm)

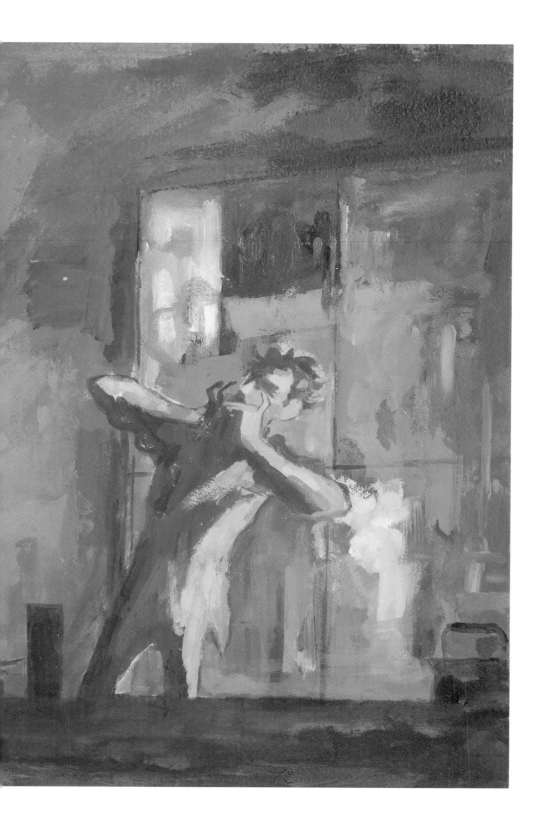

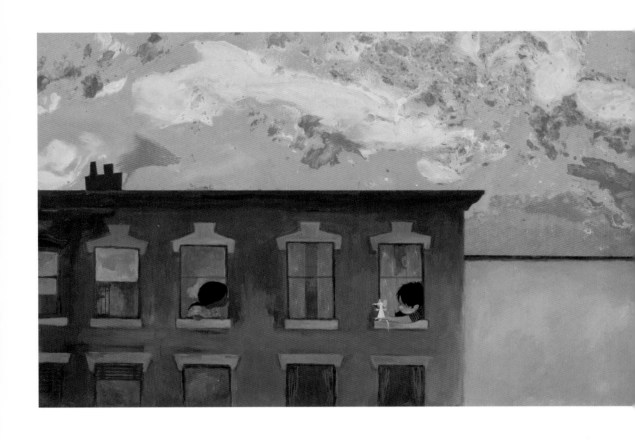

Plate 24 "It was hot. After supper Roberto came to his window to talk with Amy." Final illustration for *Dreams*, 1974. Marbleized paper and paint on board, 13 x 20½ in. (33 x 52.1 cm)

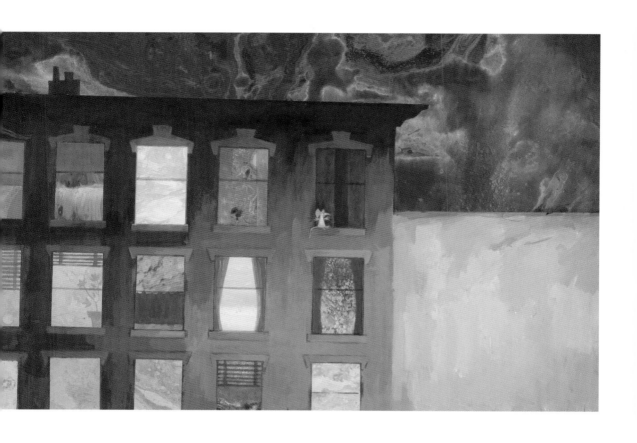

Plate 25 "Soon everybody was dreaming—except one person." Final illustration for *Dreams,* 1974. Marbleized paper and paint on board, 13 × 20½ in. (33 × 52.1 cm)

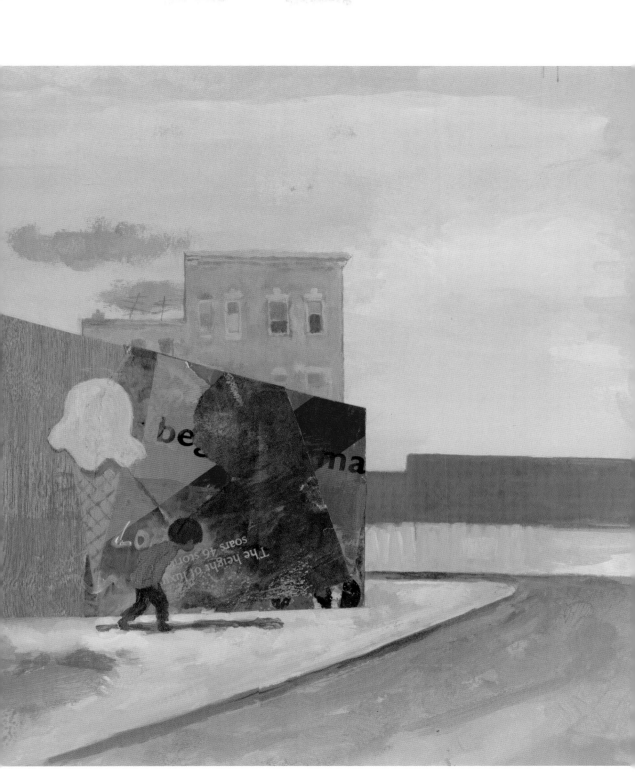

Plate 26 "Then he walked home." Final illustration for *Louie,* 1975. Collage and paint on board, 9⅞ × 19⅞ in. (25.1 × 50.5 cm)

Plate 27 "Louie took them for a ride on his plane." Final illustration for *The Trip,* 1978.
Collage, paint, and crayon on board, 12 × 22 in. (30.5 × 55.9 cm)

Plate 28 "'Maggie!
Come over please!'" Final
illustration for *Maggie
and the Pirate*, 1979.
Watercolor and collage
on board, 11⅞ × 21¾ in.
(30.2 × 55.2 cm)

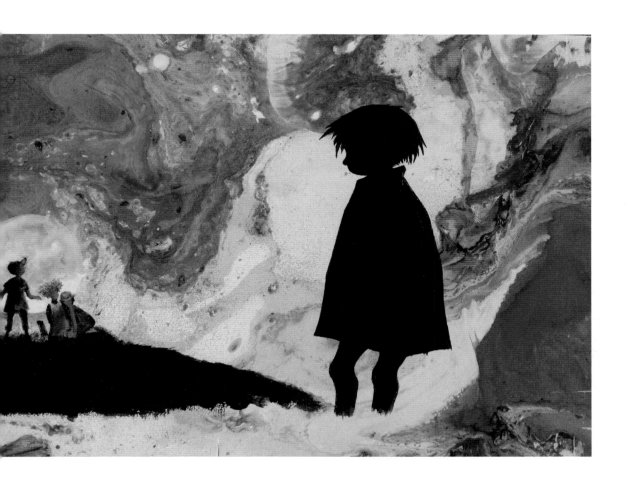

Plate 29 "Suddenly, the pirate appeared!" Final illustration for
Maggie and the Pirate, 1979. Paint on marbleized paper, mounted
on board, 11⅞ × 21¾ in. (30.2 × 55.2 cm)

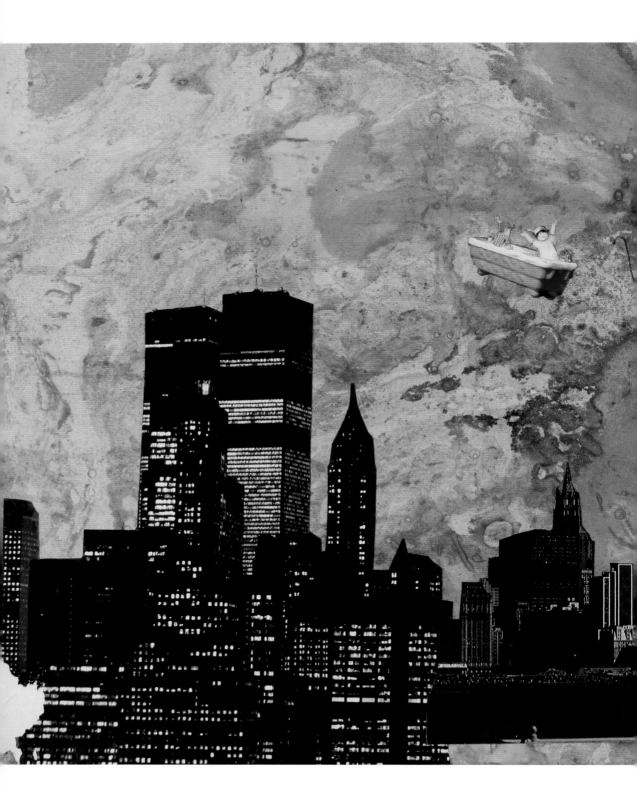

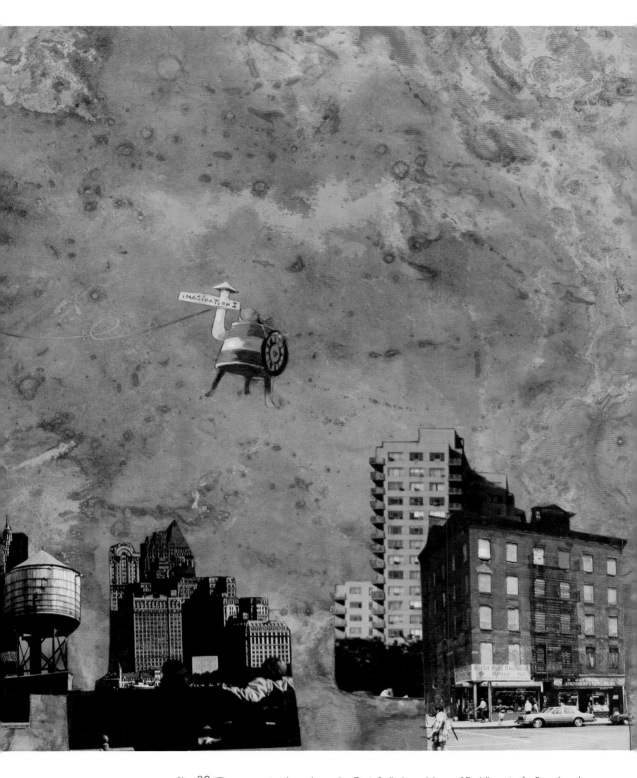

Plate 30 "They were getting close to home when Ziggie finally dropped the rope." Final illustration for *Regards to the Man in the Moon*, 1981. Collage and paint on marbleized paper, mounted on board, 12⅝ × 26 in. (32.1 × 66 cm)

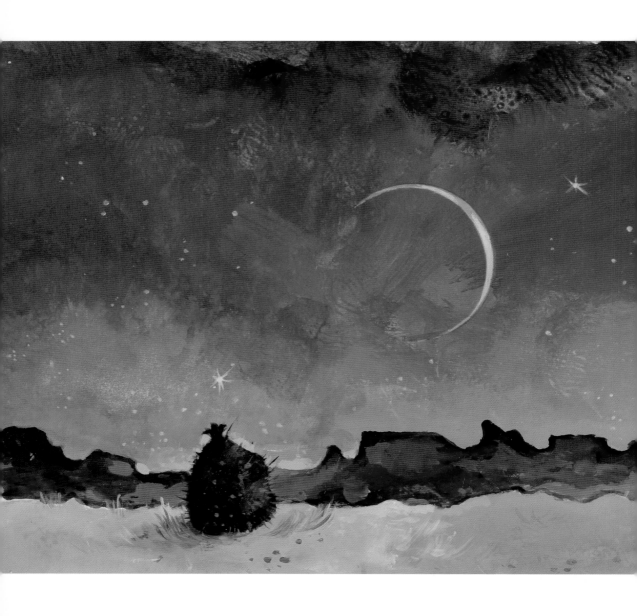

Plate 31 Clementina's cactus in the desert night. Final illustration for *Clementina's Cactus,* 1982.
Watercolor and paint on paper, 9⅛ × 19¾ in. (23.2 × 50.2 cm)

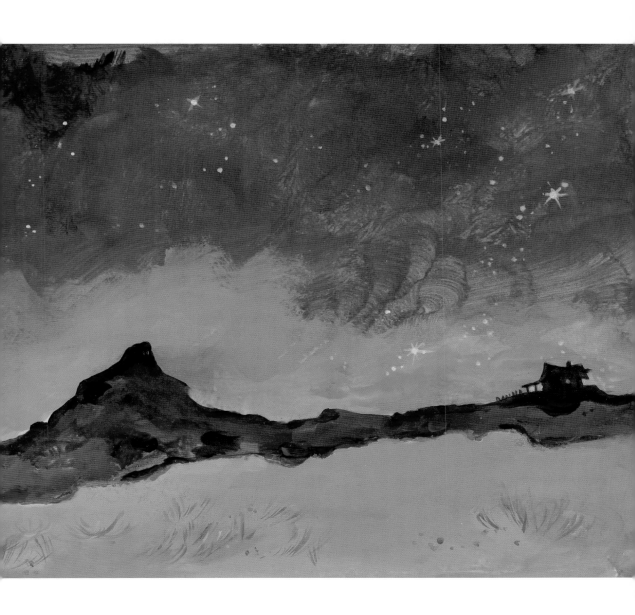

Timeline

Emily Casden and Claudia J. Nahson

1883 Keats's father, Benjamin Katz, immigrates to the United States from Poland.

1893 Keats's mother, Augusta (Gussie) Podgainy immigrates to the United States from Poland with her thirteen-year-old sister, who perishes during their journey in steerage.

1897 Augusta Podgainy and Benjamin Katz marry on December 26 (Fig. 29).

1916 Jacob (Jack) Ezra Katz, later known as Ezra Jack Keats, is born on March 11 in East New York, Brooklyn, the youngest of three children (Fig. 30).

1929–1932 Keats attends Junior High School 149 in East New York, where he befriends Martin Pope. Pope and later his wife, Lillie, will be Keats's friends for the rest of his life, making their house a second home for him.

1932–1935 Keats attends Thomas Jefferson High School in East New York.

1934 His painting *Shantytown* wins first place in a national art competition sponsored by the magazine publisher Scholastic and is shown with other prize-winning works in a traveling exhibition (Fig. 31, Pl. 1). A select few of these, including *Shantytown,* are displayed at Columbia Teachers College in New York the following year.

Keats meets the painter Max Weber, having been invited to visit his studio on Long Island.

1935 On January 23, the day before Keat's graduation from high school, his father dies suddenly.

1935–1937 Keats receives a number of scholarships to pursue art. Having taken courses at the

Educational Alliance Art School under Abbo Ostrowsky in 1934, he intermittently attends classes in New York at the Art Students League, where he studies drawing and watercolor under George Grosz, and at the Florence Cane School of Art, where he studies oil and mural painting with the renowned muralist Jean Charlot.

1937–1939 Keats finds employment as an assistant mural painter for the Works Progress Administration (WPA).

1940–1943 He works in the comics industry at, among others, Fawcett Publications, where he draws backgrounds for *Captain Marvel* comic strips (see Fig. 2).

1943–1945 Keats serves in the air force of the U.S. Army, designing camouflage patterns (Fig. 32).

1947 In December, he files a legal petition to change his name from Jacob Ezra Katz to Ezra Jack Keats. The request is granted in February 1948.

1948 Augusta Katz, the artist's mother, dies on May 8 (Fig. 33).

1949 Keats spends half a year in Paris, attending art classes at the Académie de la Grande Chaumière and painting (Fig. 34). He travels briefly to England, the Low Countries, and Italy.

1952–1963 Keats works on covers for *Reader's Digest,* and on illustrations for *The New York Times Book Review, Collier's, Playboy,* and other publications. He designs more than forty dust jackets for books, from *The Hive* by Camilo José Cela (1953) to *The Race of the Tiger* by Alexander Cordell (1963).

Fig. 29. Ezra Jack Keats. Untitled (portrait of the artist's parents), c. 1933. Oil on canvas, 30¼ × 20 in. (76.8 × 50.8 cm)

Fig. 30. Jack Katz, East New York, Brooklyn, c. 1921–1922

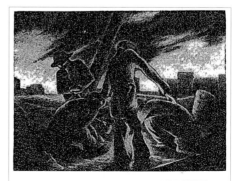

WINS NATIONAL SCHOLASTIC ART PRIZE.
"Shantytown," by Jack Katz, a student of the Thomas Jefferson High School in Brooklyn, who was awarded first place in oils in the competition sponsored by Scholastic, the national high school weekly, with the support of the Carnegie Corporation of New York.

Fig. 31. "Scholastic Prizes in the Arts Listed," with a reproduction of Keats's prize-winning *Shantytown,* from the *New York Times,* April 28, 1934

Fig. 32. Lance Corporal Katz, Third Air Force Division of the U.S. Army

Fig. 33. Memorial calendar (*Yahrzeit*) to annually commemorate the death of Keats's mother, Gussie Katz

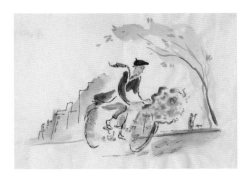

Fig. 34. Watercolor sketch done by Keats during his stay in Paris in 1949

1954 The first book for children illustrated by Keats, *Jubilant for Sure* by Elizabeth Hubbard Lansing, is published (Fig. 35). The book is set in Appalachia; Keats travels to Tennessee to sketch the landscape and people in preparation for the assignment. His art for the book paves the way for his career in children's literature. He will eventually illustrate more than sixty books for children and young adults written by other authors, from Lucretia Hale's *The Peterkin Papers* (1955) to *Penny Tunes and Princesses* (1972) by Myron Levoy (see Fig. 22).

1960 *My Dog Is Lost!* is published, cowritten with Pat Cherr. The book teaches young readers some Spanish: Juanito, with few English words in his vocabulary, gets help searching for his dog from a diverse group of characters. The book is pioneering in casting a Puerto Rican boy as its protagonist (Fig. 36).

1962 *The Snowy Day*, the first book to be both written and illustrated by Keats, is published (Fig. 37; see also Figs. 23, 25, 26, 27 and Pls. 2, 3) at the height of the civil rights movement in the United States. The main character, Peter, is the first African-American protagonist

in a modern full-color picture book. Before its publication, African-American characters either were absent from children's literature or were portrayed in a negative or stereotyped fashion. Earlier efforts in African-American picture books to present positive depictions of black children were few in number and not far-reaching. *The Snowy Day* will become an inspiration for generations of readers and children's book authors.

1963 Keats wins the Caldecott Medal for *The Snowy Day*, a recognition of the most distinguished picture book for children published in the United States during the preceding year. He goes on to write and illustrate twenty more books in the next twenty years.

1964 *Whistle for Willie* is published (Pls. 4, 5). In this book, Peter, a few years older than in *The Snowy Day*, tries and eventually learns how to whistle to his dog, Willie.

1965 "The All-White World of Children's Books," by Nancy Larrick, appears in the *Saturday Review* (September 11, 1965). Larrick sparks controversy when she criticizes *The Snowy Day* for depicting Peter's mother as a stereotypical "mammy," calling

Fig. 35. Cover of *Jubilant for Sure*, by E. H. Lansing, illustrated by Keats, 1954

Fig. 36. Preliminary illustration for *My Dog Is Lost!* 1960. Watercolor, pencil, crayon, and typescript on paper, 8½ × 14 in. (21.6 × 35.6 cm)

her "a huge figure in a gaudy yellow plaid dress, albeit without the red bandanna" (Fig. 38). Keats and many others rebuff Larrick in letters to the editor.

In a Spring Garden, edited by Richard Lewis, is published (Pl. 7). Keats illustrates this collection of haikus with poignant images.

John Henry: An American Legend is published (Fig. 39, Pls. 8, 9). Keats tells the story of the mythical strongman who hammered through a mountain while working on the railroad.

At the Venice Film Festival, a screen version of *The Snowy Day* wins the Lion of Saint Mark Award for best short film for children.

1966 *God Is in the Mountain* is published (Pls. 10, 11). Keats selects proverbs of religious and ethnic groups around the world and provides evocative illustrations.

Jennie's Hat, Keats's first story with a female protagonist, is published. Superb collages fill the book (Fig. 40, Pl. 12).

1967 *Peter's Chair* is published (Pl. 13). In the third book of the Peter series, the title character learns to adjust to the addition of a younger sister to the family.

Keats travels to Iran to attend the Second Tehran International Festival of Films for Children as a guest of honor of the Empress Farah Pahlavi. An animated film version of *Whistle for Willie* (Weston Woods Studios) is shown.

1968 *A Letter to Amy* is published (see Fig. 8 and Pls. 14, 15). Peter, now a few years older and interested in girls, decides to invite Amy to his birthday party. The artist's mastery of watercolor and collage captures the mood of a stormy day in the city.

1969 *Goggles!* is published (see Fig. 13 and Pls. 16, 17). Peter and his friend Archie must

outwit bullies in order to keep the motorcycle goggles they have found near their hideout. The book is a Caldecott Honor winner in 1970.

1970 *Hi, Cat!* is published and captures the Boston Globe–Horn Book Award (see Fig. 19 and Pls. 18, 19). In the story, Peter and Archie try to entertain their friends in the street, but an alley cat interferes.

Keats meets Fred Rogers at a forum on mass media and child development at the White House Conference on Children and Youth. Rogers invites the artist to his PBS program, *Mister Rogers' Neighborhood,* and Keats appears four times between 1971 and 1974.

1971 *Apt. 3* is published (see Figs. 15, 16 and Pl. 23). On a lonely, rainy day, Sam and his young brother Ben set out to find the source of the beautiful harmonica music filling their tenement building.

The King's Fountain, by Lloyd Alexander, is published (Pl. 22). Keats had originally created the art in the book to illustrate "Elijah the Slave," a story by Isaac Bashevis Singer, but the project did not come to fruition as intended. Instead, inspired by Keats's dramatic pictures, Alexander wrote a new story to accompany them.

Over in the Meadow is published (Fig. 41 and Pls. 20, 21). Keats furnishes luscious vignettes for this edition of the popular counting rhyme and song.

Fig. 37. "Down fell the snow—plop!—on top of Peter's head" (detail). Final illustration for *The Snowy Day,* 1962. Collage and pencil on board, 9⅝ × 20 in. (24.4 × 50.8 cm)

Fig. 38. "He told his mother all about his adventures" (detail). Final illustration for *The Snowy Day,* 1962. Collage and pencil on board, 10⅛ × 20⅛ in. (25.7 × 51.1 cm)

Fig. 39. Cover of *John Henry: An American Legend,* 1965

Fig. 40. Inspired by his own book *Jennie's Hat* (1966), Keats crafted this whimsical hat.

1972 *Pet Show!* is published (see Fig. 21). When Archie cannot locate his alley cat for the pet show, he finds a clever way to stay in the running for a blue ribbon.

1973 Keats takes his first trip to Japan, where he encounters the Ohanashi Caravan, a mobile storytelling and puppetry troupe. The company's performance of the Russian folktale "The Giant Turnip" later inspires him to illustrate the story, which he sets in Japan.

1974 Keats travels to Japan a second time, for the inauguration of a skating rink named after him and inspired by his book *Skates!* (1973), in the city of Kiyose.

Dreams is published (see Fig. 6 and Pls. 24, 25). In this story, while everyone else in his tenement building falls asleep and dreams, Roberto saves Archie's alley cat from a menacing dog. Keats's combination of paint and marbleized paper reaches a pinnacle.

1975 *Louie* is published (see Figs. 1, 20 and Pl. 26). The shy and quiet title character is captivated by Gussie the puppet at Roberto and Susie's show. Louie will be the protagonist in three more books.

1977 Keats takes his last trip to Japan, to visit Akira Ishida's parents and his grave. Akira, who died in a car accident at age nine, was an adoring fan of Keats's. The enduring popularity of his books in Japan prompts several exhibitions of his work there in the 1990s.

1978 *The Trip* is published (see Figs. 7, 14 and Pl. 27). After his family has moved away, Louie uses his creativity and imagination to travel back to his old neighborhood to see his friends.

1979 *Maggie and the Pirate* is published (Fig. 42 and Pls. 28, 29). In one of Keats's few books

not set in an urban environment, Maggie and her friends are on a mission to find the "pirate" who stole her pet cricket.

1980 *Louie's Search* is published (see Figs. 5, 9, 11). Solitary Louie sets out in search of the father figure he lacks. While scouting his neighborhood he has a run-in with a temperamental junk peddler, who unexpectedly puts an end to the boy's plight when his gentler side wins over Louie's mother.

Keats is awarded the University of Southern Mississippi Medallion for his outstanding contribution to the field of children's literature.

1981 *Regards to the Man in the Moon* is published (Pl. 30 and p. 87). Louie defies his teasing friends when his new stepfather, Barney, shows him that with a little imagination any old junk can transport him and his friend Susie into space.

1982 The artist travels to Israel with a former high school teacher, the author Florence Freedman, with whom he has remained in contact.

Clementina's Cactus is published (Fig. 43 and Pl. 31). In a story that Keats brings to life without text, little Clementina is intrigued by a prickly cactus she and her father spot while on a walk. The book is inspired by a trip Keats took to Arizona with Martin and Lillie Pope and their family.

1983 On May 6, Keats dies after a heart attack. By the time of his death he has illustrated more than eighty books for children, twenty-two of which he also

Fig. 41. ". . . in the sand, in the sun, lived an old mother turtle and her little turtle one" (detail). Final illustration for *Over in the Meadow*, by Olive A. Wadsworth, 1971. Collage and paint on marbleized paper, mounted on board, 9½ × 20 in. (24.1 × 50.8 cm)

Fig. 42. The "pirate" is on the lookout for Maggie (detail). Final illustration for *Maggie and the Pirate*, 1979. Watercolor and paint on board, 11⅞ × 21⅝ in. (30.2 × 55 cm)

Fig. 43. Clementina inspects the cactus (detail). Final illustration for *Clementina's Cactus*, 1982. Watercolor, paint, and pencil on paper, 9⅛ × 19⅝ in. (23.1 × 49.8 cm)

wrote. His book *The Giant Turnip* was near completion at the time of his death (Fig. 44).

In October, Martin Pope is elected president of the Ezra Jack Keats Foundation, which was established in 1964 but becomes more active after the artist's death. The foundation is a not-for-profit charitable organization that supports art, literacy, and family programs with funds provided by royalties from Keats's book sales.

In December, the musical *The Trip,* featuring costume and set design based on Keats's illustrations for his book of the same title (Fig. 45), debuts at the First All Children's Theater in New York (with libretto by Anthony Stein; music and lyrics by Stephen Schwartz; produced by Meridee Stein, Kurt Peterson, and Robert Reich; and directed by Meridee Stein). The musical, now titled *Captain Louie,* continues to be presented around the country today.

1984 The Keats Foundation donates the artist's papers and correspondence to the de Grummond Children's Literature Collection at the University of Southern Mississippi. A selection of Keats's works is exhibited at the de Grummond in 1988.

1986 In collaboration with the Keats Foundation, the New York City Board of Education establishes the Ezra Jack Keats Bookmaking Competition, a creative bookmaking and story-telling initiative for youngsters in grades 3 through 12.

The New York Public Library, in collaboration with the Keats Foundation, establishes the Ezra Jack Keats New Writer Award, granted biennially (and from 1999, annually) to promising children's book authors who uphold Keats's mission of multiculturalism and the universality of childhood. In 2001 the library and the foundation create the Ezra Jack Keats Illustrator Award, given annually to recognize outstanding artwork in children's books.

1993 Keats's work is featured in *Lasting Impressions: Illustrating African American Children's Books,* which opens in October at the California African American Museum, Los Angeles. Guest curated by the children's book illustrator Jerry Pinkney, the show travels to numerous venues, including the Cleveland Museum of Art (February 17–April 17, 1994); the Capital Children's Museum, Washington, D.C. (May 6–July 9, 1995); the Detroit Institute of Arts (September 2–October 29, 1995); the Lied Discovery Children's Museum, Las Vegas (November 17, 1995–January 7, 1996); the Walters Art Museum, Baltimore (February 4–March 31, 1996); and the Jane Voorhees Zimmerli Art Museum, New Brunswick, New Jersey (September 15–November 17, 1996).

1994 A Keats exhibition is held at the Children's Room of the Donnell Library Center, a branch of the New York Public Library.

1995 *Children's Artist of the City: An Ezra Jack Keats Retrospective* is on view at the Brooklyn Public Library, Central Library (January 4–February 24).

1996 Keats's work is included in *Myth, Magic, and Mystery: One Hundred Years of American Children's Book Illustration* at the Chrysler Museum of Art, Norfolk, Virginia (June 2–September 8); the Memphis Brooks Museum of Art, Memphis (November 3, 1996–January 6, 1997); and the Delaware Art Museum, Wilmington (February 7–April 6, 1997).

2000 The American Library Association Annual Conference posthumously honors Keats for his outstanding advocacy for libraries.

The National Center for Children's Illustrated Literature in Abilene, Texas, opens the

Fig. 44. "I've Never Seen a Seed Like This Before" (detail). Preliminary illustration for *The Giant Turnip,* c. 1983. Color pencil on paper, 8 × 18 in. (20.3 × 45.7 cm).

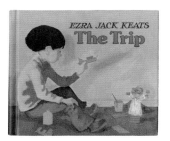

Fig. 45. Cover of *The Trip,* 1978. The book was turned into an Off Broadway musical in 1983. Now titled *Captain Louie,* it continues to delight audiences young and old through amateur productions licensed by Music Theater International.

p.87: "The next day, they told everybody about their adventures" (detail). Final illustration for *Regards to the Man in the Moon,* 1981. Paint, collage, and watercolor on board, 12½ × 26 in. (31.7 × 66 cm). Keats appears at right, brush in hand. This is the only known self-portrait where he depicts himself as an artist.

exhibition *Ezra Jack Keats: Artscapes* (November 28, 2000–February 17, 2001). Under different titles, it travels to four other venues through 2003.

2002 *Collage: An Ezra Jack Keats Retrospective* is on view at the de Grummond Children's Literature Collection at the University of Southern Mississippi (January–August).

2005 Brooklyn Recreation, Information & Culture (BRIC) establishes the annual Ezra Jack Keats Free Family Concert in Prospect Park's Celebrate Brooklyn! series.

2006 The Society of Illustrators, based in New York City, honors Keats with a posthumous Lifetime Achievement Award.

2007 Keats is featured in *Children Should Be Seen: The Image of the Child in American Picture-Book Art,* at the Katonah Museum of Art, Katonah, New York (July 1–October 21); the Eric Carle Museum of Picture Book Art, Amherst, Massachusetts (November 15, 2007–March 9, 2008); and the Los Angeles Public Library, Central Library (July 1–September 14, 2008).

2010 Keats is included in the exhibition *Drawing from a Story: Selected Caldecott Medal Winners,* at the Brandywine River Museum, Chadds Ford, Pennsylvania (March 20–May 23).

2011 The exhibition *The Snowy Day and the Art of Ezra Jack Keats* is held at The Jewish Museum (September 9, 2011–January 29, 2012), traveling afterward to the Eric Carle Museum of Picture Book Art, Amherst, Massachusetts (June 26–October 14, 2012), the Contemporary Jewish Museum, San Francisco (November 15, 2012–February 24, 2013), and the Akron Art Museum, Ohio (March–June 2013).

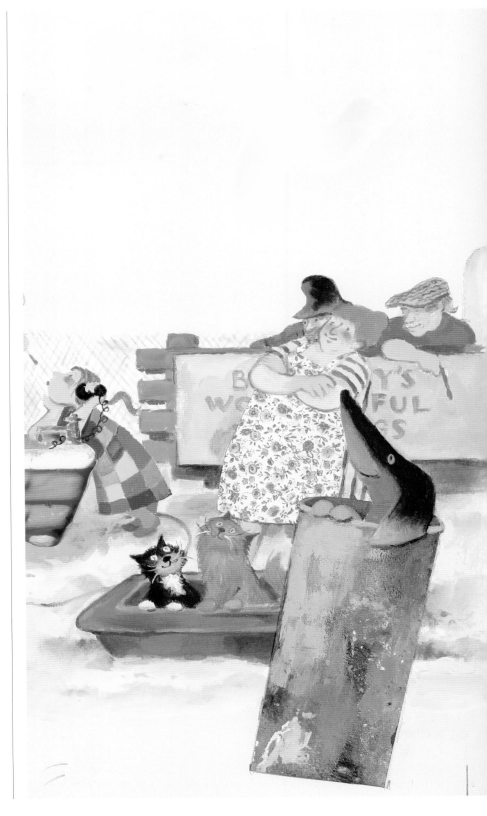

Bibliography

A Selection of Books Illustrated by Ezra Jack Keats

All books are also written by Ezra Jack Keats unless otherwise noted.

My Dog Is Lost! coauthored with Pat Cherr (1960)

The Snowy Day (1962)

Whistle for Willie (1964)

Zoo, Where Are You? by Ann McGovern (1964)

In a Spring Garden, edited by Richard Lewis (1965)

John Henry: An American Legend (1965)

The Naughty Boy: A Poem, by John Keats (1965)

God Is in the Mountain (1966)

Jennie's Hat (1966)

Peter's Chair (1967)

In the Park: An Excursion in Four Languages,
 by Esther Hautzig (1968)

A Letter to Amy (1968)

Goggles! (1969)

Hi, Cat! (1970)

Apt. 3 (1971)

The King's Fountain, by Lloyd Alexander (1971)

Over in the Meadow, by Olive A. Wadsworth (1971)

*Two Tickets to Freedom: The True Story of Ellen
 and William Craft, Fugitive Slaves,* by Florence B.
 Freedman (1971)

Penny Tunes and Princesses, by Myron Levoy (1972)

Pet Show! (1972)

Pssst! Doggie (1973)

Skates! (1973)

Dreams (1974)

Kitten for a Day (1974)

Louie (1975)

The Trip (1978)

Maggie and the Pirate (1979)

Louie's Search (1980)

Regards to the Man in the Moon (1981)

Clementina's Cactus (1982)

Selected Bibliography on Ezra Jack Keats

Alderson, Brian. *Ezra Jack Keats: Artist and Picture-Book Maker.* Gretna, La.: Pelican, 1994.

———. *Ezra Jack Keats: A Bibliography and Catalogue.* Gretna, La.: Pelican, 2002.

———. "Living on the Sidewalk." *The Times Educational Supplement,* May 15, 1992, p. 12.

Bratman, Donald. "A City Block Is the World." Unpublished interview with Ezra Jack Keats. Ezra Jack Keats Papers, de Grummond Children's Literature Collection, McCain Library and Archives, University of Southern Mississippi.

Cohl, Claudia. "Keen on Keats." *Teacher* 92, no. 3 (November 1974), pp. 45–47.

Cummings, Pat. "The Man Who Became Keats." *School Library Journal* 47, no. 5 (May 2001), pp. 47–49.

Engel, Dean, and Florence B. Freedman. *Ezra Jack Keats: A Biography with Illustrations.* New York: Silver Moon Press, 1995.

"Ezra Jack Keats." *Early Years* 11, no. 3 (November 1980), pp. 23, 103, 105.

"Ezra Jack Keats . . . the Consummate Artist . . . the Careful Writer." In *Major Authors and Illustrators for Children and Young Adults,* ed. Laurie Collier and Joyce Nakamura, pp. 1287–1291. Detroit: Gale Research, 1993.

"Ezra Jack Keats, 1916–1983." *Children's Literature Review* 35 (February 1995), pp. 82–143. This comprehensive profile includes excerpts of criticism, reviews, and commentaries on the author.

Freedman, Florence B. "Ezra Jack Keats: Author and Illustrator." *Elementary English* 46 (January 1969), pp. 55–65. Reprinted in *Authors and Illustrators of Children's Books: Writings on Their Lives and Works,* ed. Miriam Hoffman and Eva Samuels, pp. 230–242. New York: R. R. Bowker, 1972.

Hannah, Kathleen P. "'Acknowledgment for What I Do, to Fortify Me to Go Ahead': Family, Ezra Jack Keats, and Peter." *Children's Literature Association Quarterly* 22, no. 4 (Winter 1997), pp. 196–203.

Hautzig, Esther. "Ezra Jack Keats." *The Horn Book Magazine* 39, no. 4 (August 1963), pp. 364–368.

Hopkins, Lee Bennett. "On Ezra Jack Keats." *The Lion and the Unicorn* 13, no. 2 (December 1989), pp. 56–57.

———. "Remembering Ezra Jack Keats." *School Library Media Quarterly* 12, no. 1 (Fall 1983), pp. 7–9.

Huston, Margo. "Honesty Is Author's Policy for Children's

Books." *Milwaukee Journal,* March 28, 1974, part 2, p. 6.

Keats, Ezra Jack. "The Artist at Work: Collage." *The Horn Book Magazine* 40, no. 3 (June 1964), pp. 269-272.

——. Autobiographical excerpts, in *Pauses: Autobiographical Reflections of 101 Creators of Children's Books,* ed. Lee Bennett Hopkins, pp. 130-134. New York: HarperCollins, 1995.

——. "Caldecott Award Acceptance." Speech given at American Library Association meeting, Chicago, July 15, 1963. Printed in *The Horn Book Magazine* 39, no. 4 (August 1963), pp. 361-363.

——. "A Coveted Prize Reaped from Seeds Sown in Brooklyn." *Chicago Tribune,* May 12, 1963, p. 3A.

——. "Dear Mr. Keats . . ." *The Horn Book Magazine* 48, no. 3 (June 1972), pp. 306-310.

——. "Ezra Jack Keats on Collage as an Illustrative Medium." *Publishers Weekly,* April 4, 1966, pp. 94-95.

——. "Ezra Jack Keats Remembers: Discovering the Library." *Teacher,* December 1976, pp. 40-41.

——. "From COLLAGE: The Memoirs of Ezra Jack Keats." *The Lion and the Unicorn* 13, no. 2 (December 1989), pp. 58-74.

——. "The Right to Be Real." *Saturday Review,* November 9, 1963, p. 56.

——. Unpublished autobiography, n.d. Ezra Jack Keats Papers, de Grummond Children's Literature Collection, McCain Library and Archives, University of Southern Mississippi, boxes 70-76.

Lacy, Lyn Ellen. "Shape: *The Big Snow, White Snow Bright Snow,* and *The Snowy Day.*" In *Art and Design in Children's Picture Books: An Analysis of Caldecott Award-Winning Books,* pp. 144-177. Chicago: American Library Association, 1986.

Lanes, Selma G. "Ezra Jack Keats: In Memoriam." *The Horn Book Magazine* 60, no. 5 (September-October 1984), pp. 551-558.

LaRiviere, Anne. "Kid Lives On as Children's Author." *Los Angeles Times* (Orange County ed.), May 31, 1979, p. B1.

Liddick, Betty. "Capping Bessie's Flow . . . and Other Tales: Writers for Children Compare Notes." *Los Angeles Times,* August 23, 1977, p. G1.

McGovern, Ann. "An Afternoon with Ezra Jack Keats." *See-Saw Books Newspaper,* January-February 1967, pp. 8S, 11S.

Mercier, Jean F. "Ezra Jack Keats" (interview). *Publishers Weekly,* July 16, 1973, pp. 56-58.

Mikkelsen, Nina. "Remembering Ezra Jack Keats and *The Snowy Day:* What Makes a Children's Book Good?" *Language Arts* 66, no. 6 (October 1989), pp. 608-624.

Moss, Elaine. "A Mirror in the Market Place." *Signal,* no. 15 (September 1974), pp. 111-116.

Nikola-Lisa, W. "The Image of the Child in the Picture Books of Ezra Jack Keats." In *The Image of the Child: Proceedings of the 1991 International Conference of the Children's Literature Association,* ed. Sylvia Patterson Iskander, pp. 15-26. Battle Creek, Mich.: Children's Literature Association, 1991.

——. "Letters, Twigs, Hats, and Peter's Chair: Object Play in the Picture Books of Ezra Jack Keats." *Children's Literature Association Quarterly* 16, no. 4 (Winter 1991), pp. 255-258.

——. "Scribbles, Scrawls, and Scratches: Graphic Play as Subtext in the Picture Books of Ezra Jack Keats." *Children's Literature in Education* 22, no. 4 (December 1991), pp. 247-255.

Nikola-Lisa, W., and O. Fred Donaldson. "Books with a Clear Heart: The Koans of Play and the Picture Books of Ezra Jack Keats." *The Lion and the Unicorn* 13, no. 2 (December 1989), pp. 75-89.

Perry, Erma. "The Gentle World of Ezra Jack Keats." *American Artist* 35, no. 350 (September 1971), pp. 48-53, 71-73.

"Pictures Worth Looking at Twice." *The Times Literary Supplement,* November 3, 1972, p. 1326.

Pope, Martin. "Ezra Jack Keats's Neighborhood." In *The Image of the Child: Proceedings of the 1991 International Conference of the Children's Literature Association,* ed. Sylvia Patterson Iskander, pp. 53-55. Battle Creek, Mich.: Children's Literature Association, 1991.

Pope, Martin, and Lillie Pope. "Ezra Jack Keats: A Childhood Revisited." *New Advocate* 3, no. 1 (Winter 1990), pp. 13-23.

Seiter, Richard. "Ezra Jack Keats." In *Dictionary of Literary Biography,* vol. 61: *American Writers for Children Since 1960,* ed. Glenn E. Estes, pp. 116-125. Detroit: Gale Research, 1987.

Shepard, Ray Anthony. "Adventures in Blackland with Keats and Steptoe." *Interracial Books for Children Bulletin* 3, no. 4 (Autumn 1971), p. 3.

Silvey, Anita, et al. *Keats's Neighborhood: An Ezra Jack Keats Treasury.* New York: Viking, 2002.

Wilner, Isabel. Review of *The Snowy Day* and other Ezra Jack Keats books. *Growing Point* 10, no. 6 (December 1971), pp. 1840-1843.

Index

Credits

Courtesy of the Ezra Jack Keats Foundation: Figs. 1, 5–9, 11, 13, 14, 19–22, 26, 37, 38, 41–43, Pls. 2–4, 8, 9, 12–20, 22–25, 27–31, front and back covers, and pp. ii–iii, iv–v, vi, xi, xii–1, 28–29, 87. Courtesy of the de Grummond Children's Literature Collection: Figs. 2–4, 10, 12, 15, 16, 23, 25, 28–36, 39, 40, 44, 45, Pls. 1, 5–7, 10, 11, 21, 26, endpapers. Courtesy of the Library of Congress, Digital Collections, Washington, D.C.: Fig. 24. Courtesy of the Maurice Sendak Collection, Rosenbach Museum & Library, Philadelphia: Figs. 17, 18.